ISLINGTON & CLERKENWELL IN 50 BUILDINGS

LUCY McMURDO

AMBERLEY

To all former students and colleagues at City University, London, for the inspiration that motivated me to write this book.

First published 2021

Amberley Publishing, The Hill, Stroud
Gloucestershire GL5 4EP

www.amberley-books.com

British Library Cataloguing in Publication Data.
A catalogue record for this book is available from the British Library.

ISBN 978 1 3981 0145 6 (print)
ISBN 978 1 3981 0146 3 (ebook)

Typesetting by SJmagic DESIGN SERVICES, India.
Printed in Great Britain.

Contents

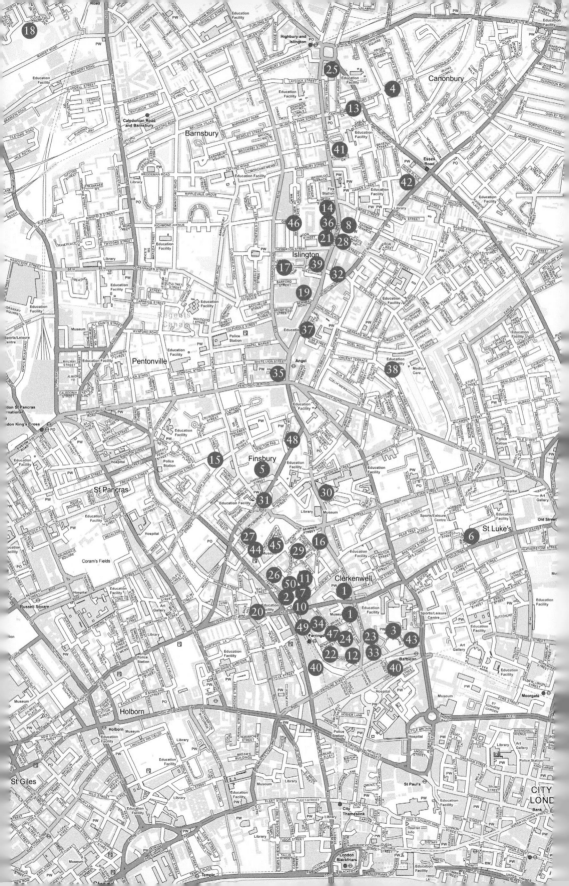

Key

How to Use This Book

In accordance with the 50 Buildings series, the buildings appear in chronological order according to the time of their original construction.

Please note that the map identifies each building by a number that corresponds to the numbers used in the text.

Introduction

The buildings in this book span 800 years and cover an amazing array of structures that chart Islington and Clerkenwell's story. They include not only housing, civic buildings, industrial and manufacturing sites, places of worship and entertainment venues, but even a tower, ventilation shaft and a well. The latter, The Clerks' Well, dates to at least the twelfth century and lends its name to Clerkenwell – a district brimming with history and located beside the City of London in the south of the borough.

Historically, Clerkenwell formed part of the borough of Finsbury, but in 1965 the boroughs of Finsbury and Islington merged to become the London Borough of Islington, which remains the local administrative body today. The present borough covers an area of roughly 6 square miles, stretching between the City of London in the south to Archway in the north, and from King's Cross in the west to Dalston and Shoreditch in the east.

Full of exciting architecture and with so many stunning buildings it has certainly been a challenge to pick just fifty buildings in Islington and Clerkenwell, as there are many more that are certainly worthy of inclusion. My main purpose in writing the book has been to provide a sense of the area's past, recount stories behind the buildings and to demonstrate why this quarter of London has such enduring appeal. I hope that the diversity of buildings selected may go some way towards the achievement of this goal.

Today Islington is one of London's most vibrant boroughs – and Upper Street, its main artery, full of pubs, clubs, bars, cafés and restaurants, has justly earned the nickname 'Supper Street'. This, however, is nothing new as hostelries and inns have had their place here for hundreds of years. It has always been the main street along which shepherds herded their animals en route to slaughter at Smithfield Market, and many of them were accustomed to stop for refreshment or break their journey here while fattening up the cattle and sheep.

Originally Islington, or 'Yseldon' as it was known in the Middle Ages, was a small village just outside the walls of the City of London and set amid meadows and fields, forest and farmland. Full of springs, rivers and ponds the area was a recreational destination for nobles and royalty who came here to hunt and practice archery. The wild bulls, boars and stags that roamed its woods made Islington a most popular retreat. It also had a thriving dairy industry and many of its high-quality foods – its milk delicacies, fresh curd cheeses and baked custard tarts – were favoured by the court and London's wealthy.

Clerkenwell, south of Islington, also had a strong association with the dairy trade and in the eighteenth century was where many Welsh dairy workers settled with their families. In fact, the Marx Memorial Library on Clerkenwell Green was initially built as a charity school for the children of Welsh artisans. From the late twelfth century three major religious communities – the Priory of St John, St Mary's Nunnery and the Charterhouse – were established here, attracted to the district because of its plentiful waters found in its springs and the River Fleet. When these monastic settlements were dissolved in the 1530s the Crown confiscated much of their land and estates, but the Norman crypt of St John's Priory and some of the Charterhouse's buildings were left intact and today remain some of the area's greatest treasures.

Even though water had always been a major feature of both Islington and Clerkenwell, the New River (not actually a river at all but a man-made canal) was constructed in the early 1600s to transport much-needed water to London from springs in Hertfordshire. Arriving at a terminus close to Sadler's Wells, it was then distributed via hollowed elm pipes into people's homes. Sadly, little evidence now exists of the original New River filter beds and buildings, but one can still get a glimpse of its eighteenth-century windmill base and engine and pump house in Amwell Street. Nowadays, the New River is mainly a subterranean waterway, but a small stretch flows above ground set in pretty gardens in Canonbury and gives a sense of what the waterway must once have looked like.

In fact, most of Islington was rural until the 1800s, but rapid industrialisation changed its character overnight as fields and meadows were covered with factories, warehouses and depots. Terraced housing was built for the burgeoning population and from the 1820s developers laid out handsome Georgian squares in a wide range of architectural styles for the middle classes. This was a time of great change. The Regent's Canal opened in 1820, followed by the railway in 1863 and the underground in 1901. The Victorians were not just great engineers and inventors, but took tremendous pride in what they built. Islington and Clerkenwell's civic buildings, music halls, theatres, factories and warehouses were adorned with terracotta, wrought iron, stucco and stone and were made to look all the more interesting by the embellishment of patterned brickwork, ornate windows, iron railings and balconies. Excellent examples of this architecture can be seen at Old Finsbury Town Hall in Rosebery Avenue and at the Union Chapel and former Royal Agricultural Hall in Upper Street.

Industrialisation resulted in enormous population growth too, and Clerkenwell in particular suffered from great overcrowding. Being located so close to the City, it became a sanctuary for many seeking work and its numbers swelled threefold in the first half of the nineteenth century. Immigrants came from France, Prussia and Germany as well as Ireland and Italy. In fact, there were so many Italians in Clerkenwell that the area they settled in (around today's Clerkenwell Road) became known as 'Little Italy', with St Peter's Italian Church at its heart.

As the century drew to a close people moved away to the surrounding suburbs and the area began its steady decline. By the mid-twentieth century war damage and general neglect made many of its buildings appear exceedingly shabby, and Islington and Clerkenwell were far from the classy expensive districts we know today. In fact, when London's Monopoly board hit the market in the 1930s The Angel at Islington was one of its cheapest properties, reflecting its down-at-heel appearance and people's perception of the area at the time. Fortunately, by the 1960s the borough's fortunes began to change: Camden Passage became renowned for its antiques market attracting visitors from around the globe. This led to the restoration by property speculators of much of the area's housing stock, including many properties in Islington's elegant Georgian squares. As a result of this gentrification there was an influx of new wealthy residents, many from the professional classes, the media and politics. The latter included politicians such as Tony Blair, Jeremy Corbyn, Margaret Hodge and Emily Thornbury as well as Boris Johnson before he became prime minister and moved into Downing Street.

Today, many of the beautiful and historic buildings in Islington and Clerkenwell are protected, some included within Islington Council's Conservation Areas, while others fall under the protection of the national body, English Heritage, as 'listed' buildings. Throughout this book you will see reference to such buildings being designated Grade I, II* or II status, and the rankings (from Grade I at the top) denote the national architectural and historic significance of each building. Through such listing these buildings are protected for future generations, and alterations can only be made once listing consent has been given. It is both exciting and encouraging to see that English Heritage's Register of Listed Buildings now recognises a wider range of architectural styles and that the house designed in 1988 by Piers Gough for the broadcaster and journalist Janet Street-Porter is today Grade II listed (see page 89).

Certainly, there is much to explore in Islington's and Clerkenwell's streets, so stroll around the neighbourhood, walk down its side streets and always look up, where you are sure to catch sight of unexpected friezes, carvings and beautiful statues. With so many architectural styles and a wonderful historic atmosphere there is always something new to experience in Islington and Clerkenwell.

The 50 Buildings

1. St John's Gate, Church and Museum

This magnificent sixteenth-century, stone, palatial gateway just off the Clerkenwell Road was once the main entrance to St John's Priory, a religious settlement of Crusader monastic knights known as the Knights Hospitaller. The priory, built in the 1140s, was the English headquarters of the Order of St John and stretched across 10 acres, encompassing its church, cloisters, a dormitory, kitchens, slaughterhouse, an armoury and a brewery. Important dignitaries and even royalty were known to have stayed here and it was considered to be one of the most powerful institutions outside the City of London until the order was dissolved in 1540 at the time of the Reformation. At this point the buildings and land were sold off, although the church continued in use first as a private chapel

St John's Gate. (© A. McMurdo)

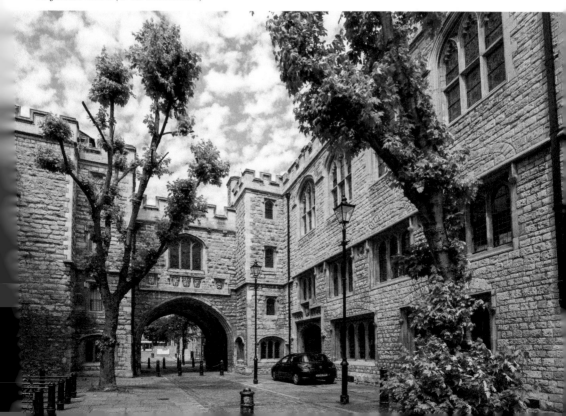

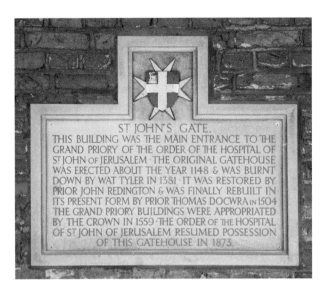

St John's Gate plaque.
(© A. McMurdo)

and ultimately as a parish church. Over the centuries the gate was used as the Master of Revels' office where Shakespeare and Ben Johnson obtained licences for their plays, as a coffee house, a tavern, home to *The Gentleman's Magazine* and a watch-house. In the late nineteenth century, in recognition of the work of the St John Ambulance Association, Queen Victoria re-established the order as the Most Venerable Order of St John, and it became a British Royal Order of Chivalry. Since 1888 the reigning monarch has been the sovereign head of the order and a senior member of the royal family nominated as the Grand Prior.

Priory Church of the Order of St John. (© A. McMurdo)

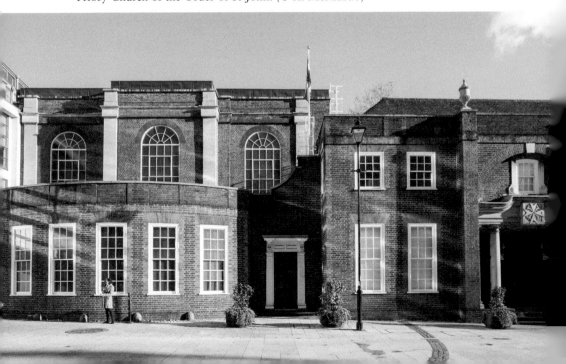

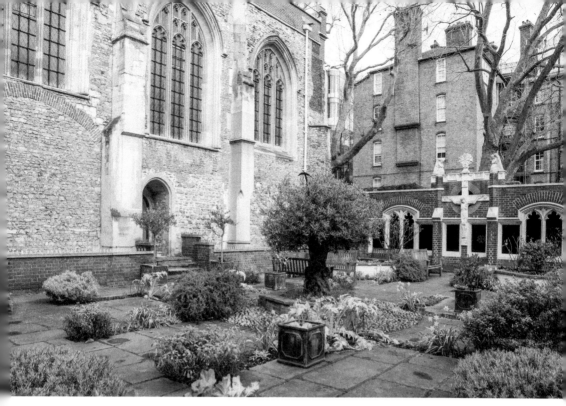

Cloister Garden, Museum of the Order of St John. (© A. McMurdo)

Today, the history of the knights and the order is beautifully brought to life within St John's Gate. You can visit the museum and also join regular tours of the building where you will see the Chapter Hall, Council Chamber, Malta Room and the Tudor staircase. The tour also includes a visit to the priory church, with its stunning twelfth-century Norman crypt. Although the original priory church disappeared many centuries ago, a circular line of black stones in front of the present building represents the round nave of the 1185 church (based on the Church of the Holy Sepulchre in Jerusalem). Nowadays the priory church is used for the order's services and investiture ceremonies.

Website: www.museumstjohn.org.uk
Stations: Farringdon, Barbican

2. The Clerks' Well, No. 16 Farringdon Lane

During the Middle Ages the parish clerks of London participated in annual biblical plays beside the 'fons clericorum', a well sited beside the Nunnery of St Mary, which today encompasses the space around Clerkenwell Green. The well was located beside the River Fleet, a popular London resort found to be particularly pleasing on account of its abundant waters. In 1174 the neighbourhood was described by Fitzstephen, a former secretary to Archbishop Thomas Becket, as an

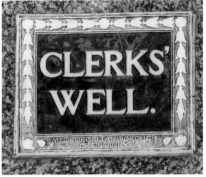

Above: The Clerks' Well plaque.
(© A. McMurdo)

Left: The Clerks' Well.
(© A. McMurdo)

area of 'excellent suburban springs, with sweet, wholesome and clear water ...' Each year huge crowds were known to gather here to see the 'miracle' plays, performances of the Holy Scriptures by the parish clerks. As a consequence, the site became known as the Clerks' Well and subsequently lent its name to the entire district that became known as Clerkenwell.

In the twelfth century locals could access the well's good mineral waters via a pipe in the nunnery's wall, but this ceased following the Dissolution of the Monasteries (1536–40) when many of its buildings were demolished. It was not until the 1670s that the new landowner, the Earl of Northampton, donated the well for use by the parish poor and a fountain was provided beside the old nunnery wall.

By 1800 the pump was raised to the level of the pavement and a plaque remembering the parish clerks was put in place. By this time the well's water supply had reduced considerably, which may be why the present round well was sunk – to offer a better source for the pump. Sadly, by the middle of the century the well had become so polluted that it was closed by the authorities. It was built over and remained unused and undiscovered until 1924 when Nos 14–16 Farringdon Lane was being rebuilt. After a complete refurbishment the well was enclosed within the office block and today is visible through glass windows facing the street. If you join a tour of the local Clerkenwell and Islington guides (www.

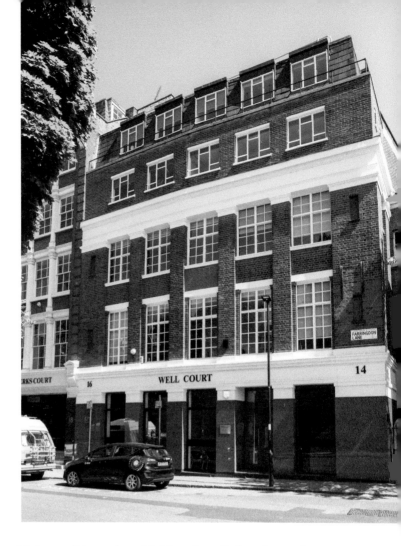

Well Court.
(© A. McMurdo)

islingtonguidedwalks.com) it is possible to view this historic well chamber and see the 1800 pump along with its Tudor brick and seventeenth-century stone walls.

Station: Farringdon

3. The Charterhouse and Museum, Charterhouse Square

Tucked away in a corner of the square, this is certainly one of Clerkenwell's most delightful treasures. The Charterhouse, founded by Walter de Manny, a soldier, courtier and senior advisor to Edward III, was established in the late 1300s as a Carthusian monastery. Built beside a plague pit for those who had died during the Black Death (1348), the monastery accommodated a prior and twenty-four monks as well as lay staff. The monks, living in separate two-storey houses around a large cloister, led an austere and solitary existence, spending much of the day in prayer and meditation in the priory church, only speaking on Sunday

and religious holidays. When the monastery was suppressed in the religious turmoil of the 1530s most of the monks, including the prior, lost their lives and the Charterhouse land and buildings passed to the Crown. The king later granted the estate to one of his nobles, who built himself a grand house that replaced some of the former monastery buildings. In 1611 the Tudor house and grounds were sold for £13,000 to Thomas Sutton, said to be the most prosperous commoner in England at the time. He had accumulated his wealth by dealings in the coal trade, property and money lending and purchased Charterhouse for use as a boys' school and as an almshouse for poor gentlemen. The school quickly gained a top reputation and has a list of famous alumni, including the Methodist leader John Wesley (1703–91), the writer J. M. Thackeray (1811–63) and the founder of the Boy Scouts movement, R. Baden-Powell (1857–1941). When the school moved to new premises in 1872 the elderly gentlemen remained and since 2018 they have been joined by three women who interestingly are still all addressed as 'brothers' in deference to Charterhouse's monastic past.

Nowadays one can visit the museum and chapel or join a tour of the wonderful sixteenth-century buildings where you will see the Great Hall, the Great Chamber and fourteenth-century Norfolk Cloister. Wonderfully atmospheric, it is no wonder that Charterhouse is an events venue and is where many movies and TV series have been filmed.

Website: wwwthecharterhouse.org
Stations: Farringdon, Barbican

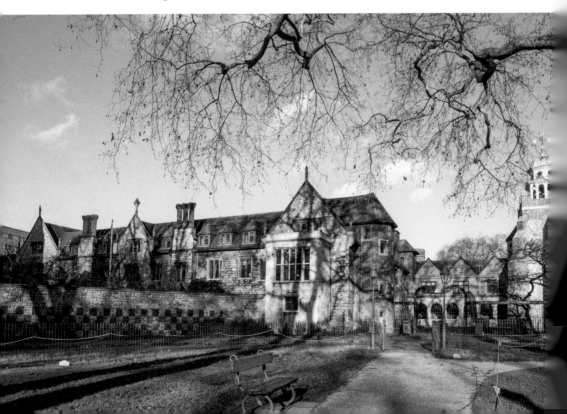

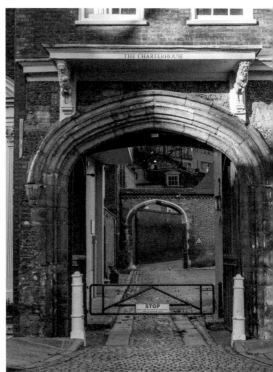

Opposite, above and right: The Charterhouse.
(© A. McMurdo)

4. Canonbury Tower, No. 6 Canonbury Place

The building of Canonbury Tower coincided with the start of Henry VIII's reign in 1509. Its original purpose was as a peaceful country retreat for Prior Bolton of St Bartholomew's of Smithfield, away from the area's market, smells and executions. Today, wedged in among housing, Canonbury Tower is Islington's sole remaining example of Tudor domestic architecture and boasts superb architectural features including beautiful oak wood panelling. The tower was largely rebuilt in the 1570s but evidence of its original builder, Prior Bolton, is illustrated in his rebus displaying a bolt (arrow), piercing a tun (barrel), a sample of which can be found on the summer house at No. 4 Alwyne Villas. Not only was this Bolton's building mark, it was also a pun on his name.

Throughout its history Canonbury Tower has had exceptional links with prominent statesmen and also luminary literary figures. Following the dissolution, the property became Crown property and was granted first to Henry VIII's chief minister, Thomas Cromwell (1485–1540), and later to a series of court nobles. When Elizabeth I (1533–1603) ascended the throne one of her favourite courtiers and Lord Mayor of London, Sir John Spencer, purchased the tower, transforming it into a comfortable home. Spencer refused to support the marriage of his feisty daughter Eliza to a penniless noble, Lord Compton, and confined her to her rooms

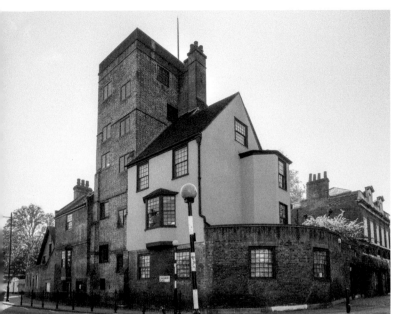

Above left and above right: Canonbury Tower. (© A. McMurdo)

hoping she would see sense. Imagine his surprise when he discovered not only had she escaped, supposedly having been lowered down in a basket from the tower but had eloped to marry her lover. Fortunately, the story has a happy ending as Elizabeth I surreptitiously brought about the reconciliation between Spencer and his daughter and in due course Compton inherited his wife's wealth and became the Earl of Northampton.

In later years Canonbury Tower has been occupied at various times by the philosopher and statesman Sir Francis Bacon (1561–1626) and the writers Oliver Goldsmith (1728–74) and Washington Irving (1783–1859), both of whom occupied the Spencer Room. Today tours of the building, lasting around 90 minutes, are offered through the excellent local Clerkenwell guides. Refer to www.islingtonguidedwalks.com for further information.

Stations: Highbury & Islington, Canonbury

5. New River Head Buildings, Rosebery Avenue

Today, very little remains of the circular 200-foot water basin that occupied the area around the New River Company's headquarters for around three centuries. This was the terminus of the New River, not a real river but a manmade waterway, bringing clean water into the City of London from springs in Hertfordshire. Flowing along a 38-mile course, the channel was 10 feet wide and 4 feet deep

and took four years to construct. It was a major enterprise involving numerous labourers and carpenters who were paid at rate of $4d$ and $6.5d$ per day, respectively. Its inventor, Edmund Colthurst, was given permission to start on the project in 1604 but soon ran into funding problems so the work was ultimately taken over by the MP and wealthy Welsh goldsmith Hugh Myddelton (1560–1631). He, too, ran into financial difficulties, but with the king's assistance managed to complete the waterway in 1613 and received both a knighthood and a baronetcy for his part in the works.

The terminus basin was actually made up of an inner and outer pond, the former discharging water into the latter, and then distributed to homes in the City via hollowed elm pipes. By 1709 a new reservoir was required, and this was built a short

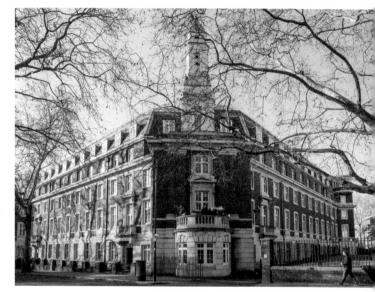

Right: New River Head office. (© A. McMurdo)

Below: New River Head laboratory building. (© A. McMurdo)

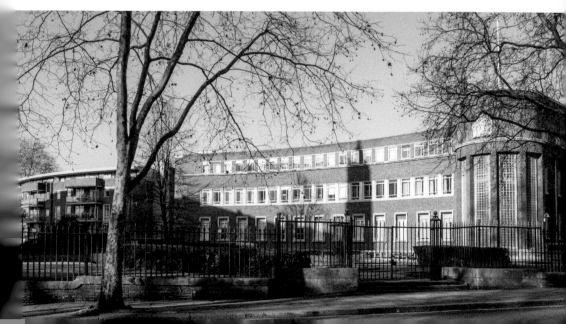

distance away on a hilltop (today's Claremont Square). A six-sailed windmill was erected on the site so that water could be pumped up there, but itself was replaced by two horse-gins as wind power proved unreliable. Remnants of the windmill and the 1768 engine and pump house buildings remain visible from nearby Amwell Street, but the original water building has long since disappeared. However, its board room, the Oak Room, famed for magnificent carvings by Grinling Gibbons, was incorporated into the New River Head building when it opened in 1919.

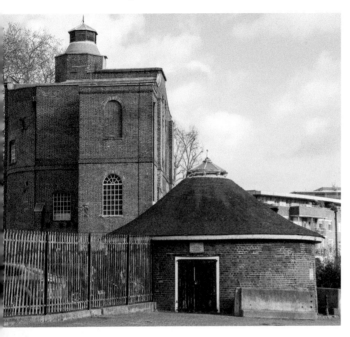

Left: New River Head windmill base and pump house. (© A. McMurdo)

Below: The New River and Watchman's Hut, Canonbury. (© A. McMurdo)

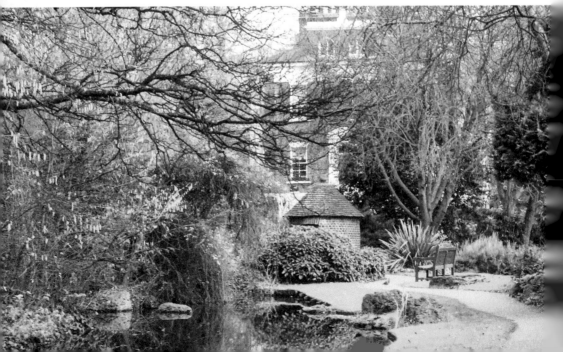

Nowadays the New River flows mainly below ground, yet still, 400 years after its creation, it supplies drinking water to 700,000 Londoners and plays an important role in London's water system. In recent times the New River Head and Laboratory buildings have been converted from Thames Water offices into comfortable apartments.

Stations: Angel, Farringdon

6. St Luke's Church, Old Street

After a period of dilapidation and neglect this wonderful eighteenth-century church underwent a complete refurbishment in the early 2000s and today houses the London Symphony Orchestra's (LSO) Music Education Centre. Sponsored by UBS, the global wealth management company, and with funding from the Arts and Heritage Lotteries, St Luke's has now been restored to its former splendour; it is today in a position to meet both the needs of a contemporary orchestra and offer suitable space for educational activities. Much of the former church interior, including the walls and window alcoves, has been preserved, but four enormous steel columns, looking similar to tree branches, now support the roof. From

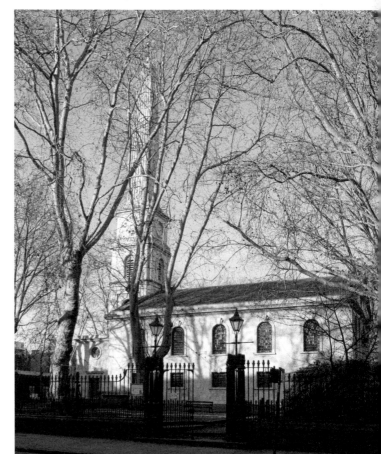

Right and overleaf: St Luke's Church. (© A. McMurdo)

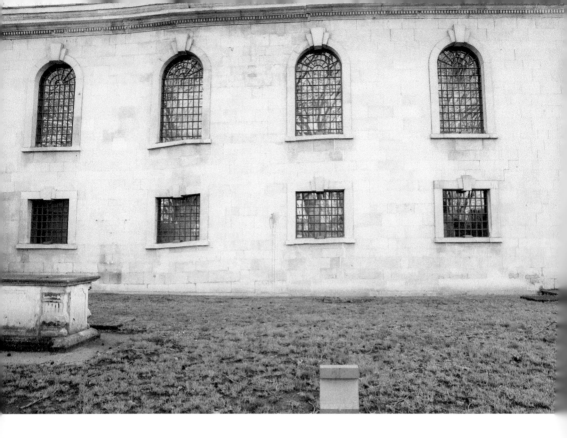

the time it opened in 1733, St Luke's suffered from subsidence (it was built on marshland) and evidence of this is still clearly illustrated by its decidedly wonky windows facing the rear churchyard. In 1959, when the columns supporting the church roof were found to be hanging off it, the building was declared unsafe and forced to shut. For a church that had attracted large congregations throughout its existence and was so much part of the community its closure was heartbreaking. Only a century earlier St Luke's had been so popular that carriages were regularly lined up on Old Street as they dropped off its wealthy parishioners.

The church was constructed in the wake of the New Churches Act of 1711, which envisaged fifty new churches for London's flourishing population. In the event only twelve of the number were built and by the time work began on St Luke's there was little money left in the pot, which most probably affected the quality of its construction. It is not clear who was actually responsible for the project, but it is believed that the architects John James (1673–1746) and Nicholas Hawksmoor (1661–1736) played a major role in its design. Nowadays, St Luke's is considered a local landmark due to its tall obelisk spire, generally attributed to Hawksmoor. The dragon on the brass weathervane surmounting the spire was mistakenly thought to be a louse for many years and gave rise to the church's nickname, 'Lousy Luke's'.

Website: www.lso.co.uk
Station: Old Street

7. Marx Memorial Library, No. 37a Clerkenwell Green

The Marx Memorial Library sits within a beautiful eighteenth-century house originally constructed as a charity school for Welsh children. With its imposing pediment and Georgian façade, it is easily identified. Today the library is renowned for holding an enormous collection of works relating to the working-class movement, the history of socialism and the science of Marxism. The library contains more than 60,000 books, pamphlets and periodicals, and visitors have access to archival collections of the Spanish Civil War, the International Brigade, the women's movement, trade unionism and peace and solidarity. Many of its resources are totally unique and unavailable elsewhere.

The library was founded by the London labour movement and opened in 1933. Before this time the building had been largely associated with radical organisations and from the early 1890s it was occupied by a left-wing printer, The Twentieth Century Press (TCP), which published its weekly journal, *Justice*, here. While exiled in Clerkenwell in 1902–03 Lenin (1870–1924) used TCP's offices to produce his newspaper, *Iskra* ('The Spark'), which was then smuggled into Russia. The office Lenin used at this time can still be seen on the first floor of the library, as can the celebrated mural painting *The Worker of the Future Upsetting the Economic Chaos of the Present* by Viscount Hastings. Interestingly, the library is the only British building to be so closely linked with Lenin.

Marx Memorial Library. (© A. McMurdo)

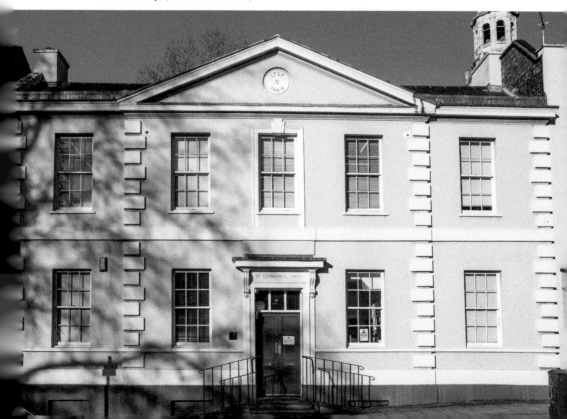

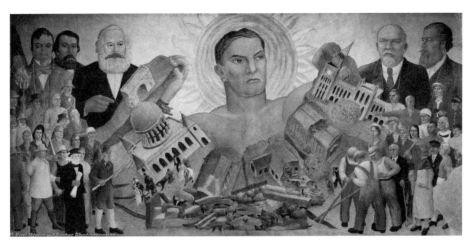

Marx Memorial Library mural. (© Karl Weiss)

In the early 1700s rapid urbanisation and an ever-growing population (countless Welsh dairy workers had moved here for work) meant that children were growing up in dire poverty, which ultimately led to the establishment of charity schools. The Welsh school opened in 1737, aiming to provide children with basic skills that would allow them to access gainful employment. It then moved to larger premises in the 1770s and the building was subsequently used for a variety of purposes, including a bicycle shop, haberdashers, chemists, coffee house and even a mattress maker.

In 1987 archaeological work beneath the building discovered a number of barrel-vaulted tunnels that predate the building, possibly part of a network between the former twelfth-century St Mary's Convent (see page 28) and the nearby Sessions House (see page 26).

Website: www.marx-memorial-library.org.uk
Station: Farringdon

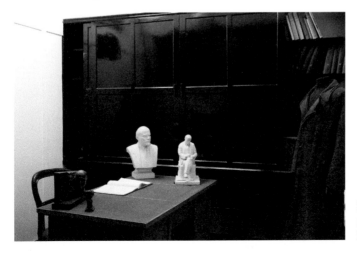

Lenin's desk. (© Marion Macalpine)

8. St Mary's Parish Church, Upper Street

St Mary's Parish Church is a major focal point along Upper Street, situated halfway between Highbury and the Angel, and its imposing brick and flint tower and spire are clearly visible from many vantage points in the area. The fine Portland stone portico fronting the west door contains a beautiful relief of the Nativity and was designed by the architect Sir Reginald Blomfield (1856–1942) in 1904.

St Mary's is Islington's oldest church: it is thought to be at least 900 years old, possibly dating back to Anglo-Saxon times. Until the eighteenth century it was the only place of worship here, but once the area began to develop more parishes were created to serve the community. This resulted in the construction of additional churches and chapels-of-ease in the nearby streets and squares, some of which moved away from the Church of England tradition and followed Nonconformist principles.

Below left and below right: St Mary's Parish Church. (© A. McMurdo)

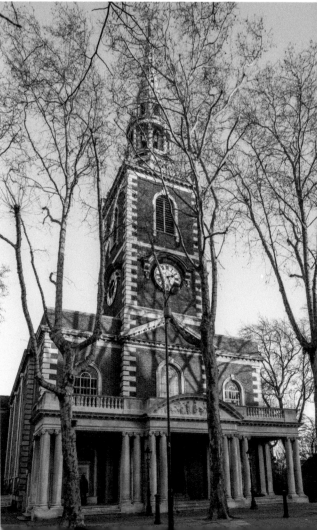

The church we see today is at least the fourth building on the site and was largely rebuilt in the 1950s after suffering severe bomb damage during the Second World War. Amazingly, the entrance porch and the tower and steeple of the earlier eighteenth-century church managed to survive the devastation, but the roof, main body of the church and the churchyard were badly affected. The fact that so much of the 1750s church remained standing says much for its design by Lancelot Dowbiggin (1689–1759).

During the 1700s the Nonconformist Wesley brothers John (1703–91) and Charles (1707–88) and their colleague George Whitfield (1714–70) all preached at the church. It was while Charles was the church curate between 1738 and 1739 that both he and John were banned from preaching in St Mary's, as their sermons so scandalised the Church authorities.

During the twentieth century the church benefited from the work of three curates, two of whom – Donald Coggan and George Carey – later became Archbishops of Canterbury; the third, the England cricketer David Sheppard (1929–2005), became Bishop of Liverpool.

Today, weekly Sunday services are held within the church and St Mary's remains a great community hub, offering courses and events in its Neighbourhood Centre and in the church crypt.

Website: www.stmaryislington.org
Stations: Angel, Highbury & Islington

9. Wesley's Chapel and Leysian Mission, No. 49 City Road

Wesley's Chapel, designed by George Dance the Younger, was opened in 1788 opposite Bunhill Fields. The chapel, which John Wesley (1703–91) described as 'perfectly neat, but not fine', was built to replace the Foundry Chapel in Moorfields, his previous base.

Today the chapel is the 'Mother Church of World Methodism', renowned for its beautiful stained-glass windows, oak pews and the altar rails donated by Baroness Thatcher (who was married here in 1951). Hordes of visitors regularly arrive to pay homage to the building and its founder and also to visit Wesley's tomb in the garden and the Wesley Museum in the crypt. The latter contains many objects, documents and paintings relating to Methodism, and charts its origins and spread. Wesley's House, where Wesley spent the last years of his life, is also open to visitors and is an excellent example of a typical middle-class, eighteenth-century home. It contains his study as well as his famous electrical machine for nervous disorders. Close to the house stands an impressive statue of John Wesley displaying a soberly dressed man in eighteenth-century attire. His demeanour and fastidious appearance seem to substantiate what is known about Wesley's self-discipline and purpose.

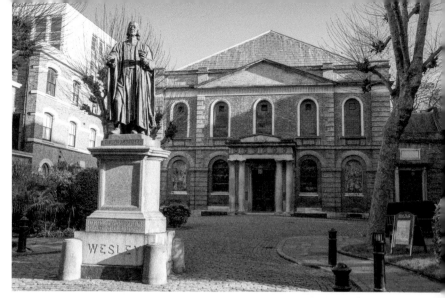

Wesley's Chapel.
(© A. McMurdo)

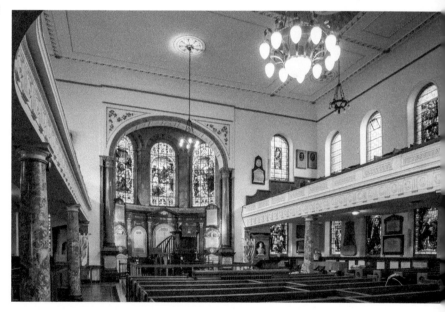

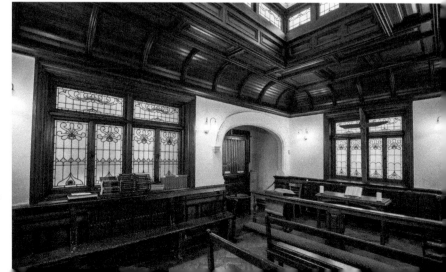

The Foundry
Chapel.
(© A. McMurdo)

John Wesley was born into a poor church family. His father was a rector and John and was one of nineteen children. He first attended Charterhouse School in Clerkenwell and later went on to study at Oxford University. While there he and his younger brother Charles (1707–88) became part of a group that believed religion should govern everyday activities. Fellow students referred to them as 'Methodists' on account of their highly disciplined lifestyle, their attention to Bible studies and focus on time management.

On completing his studies John became an Anglican priest, but as his sermons went beyond the orthodox teachings of the Anglican Church he found himself banned from their pulpits. He then took to preaching in the open air, meetings that were attended by the masses, especially the new industrial working class. A prolific writer, John Wesley published many books and pamphlets and travelled the length and breadth of the country spreading his word, until his death in 1791.

Website: www.wesleyschapel.org.uk
Station: Old Street

1C. The Old Sessions House, Clerkenwell Green

This is one of the area's most iconic buildings and is found facing Clerkenwell Green just across from the Marx Memorial Library (see page 21). Established in 1782 as the Middlesex Sessions House (courthouse), it rapidly gained a reputation for meting out the harshest sentences in the country and was consequently feared by all prisoners who came here. The building was constructed during the reign of George III, a time when it was common for convicts to be transported to the newly formed colonies such as Australia. Some of those tried here were fortunate only to be placed in the stocks on Clerkenwell Green, but those found guilty of greater offences could be immediately shipped overseas after sentencing, with no prospect of an appeal, filling boats moored behind the courthouse on the River Fleet.

The Sessions House was designed by the Middlesex county surveyor, Thomas Rogers, and built between 1879 and 1882 at a cost of £13,000. It was built to impress; constructed in Portland stone with its four-storey façade, central portico, Iconic columns, coat of arms and medallions of Justice and Mercy (the work of J. Nollekens), one has no doubt that it was an important building. Inside, apart from its miserable, tiny, dark and windowless prison cells, the Old Sessions House was fitted out in lavish style. It contained judges' robing rooms, consulting rooms, two courts, dining rooms and living accommodation for resident lawyers.

The courthouse finally shut down in 1921 and then became the headquarters of the weighing scales manufacturer Avery until the early 1970s. It was later taken over by the Freemasons, who transformed it into a conference centre. Now, once again, it has new owners. A massive restoration has taken place and enormous attention has been applied to return the Old Sessions House to its former glory, displaying its exquisite Georgian and Victorian features. Today it is marketed as a

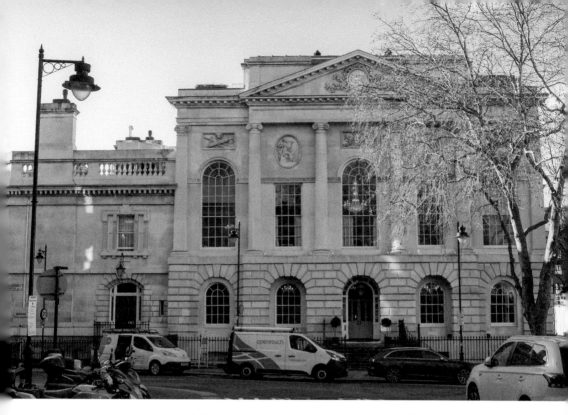

Above, below and right: The Old Sessions House.
(© A. McMurdo)

meetings and events venue offering bar and restaurant facilities and comes under the portfolio of Ennismore hotels.

As with many old buildings, it is said to be haunted. Many have claimed to see a weeping woman on the main stairwell, apparently mourning her recently transported lover.

Station: Farringdon

11. Clerkenwell Green: St James's Church and the Crown Tavern

Clerkenwell Green has a long and fascinating history dating from its monastic origins in the twelfth century to its subsequent use as a point of riot, assembly, radical politics and demonstration. It has had considerable association with the law and the working classes (see 'Old Sessions House and Marx Memorial Library', pages 26 and 21), as well as with literary figures such as Charles Dickens and Izaak Walton. As one of Clerkenwell's most cherished enclaves it benefits from designation as a conservation area, allowing for the preservation of much of its historic charm.

The Benedictine Nunnery of St Mary's was founded here in the 1140s on a plot of land close to the Priory of St John's (see page 9). The community, with its fifteen to twenty nuns as well as servants and laypeople, was small but wealthy, possessing its own church, mill, meadows and fish ponds. In 1539, when the nunnery was dissolved, it was the twelfth richest monastic house in England. Of all the nunnery's buildings, only the church survived, becoming the parish church of St James. The church was completely rebuilt in the 1780s, altered during the

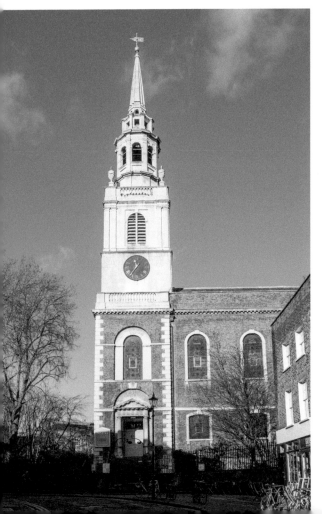

St James's Church (© A. McMurdo)

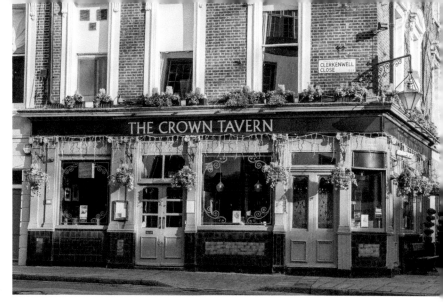

The Crown
Tavern.
(© A. McMurdo)

Victorian period and possesses some unusual features such as the curved west end and double upper gallery (built for the charity children in the 1820s). St James's atmospheric crypt, with its brick vaulted ceiling and columns, is now used as a venue for wedding receptions, exhibitions and film shoots.

Clerkenwell Green, too, is often seen as a backdrop in TV programmes and films and moviegoers will quite possibly recognise scenes from *Paddington 2* (2017) and *A Fish Called Wanda I* (1988) that were shot here.

The Crown Tavern located on the corner of Clerkenwell Close is where the British film *Notes on a Scandal* (2006), starring Judi Dench and Cate Blanchett was filmed. The pub is typical of the Victorian age and oozes with character; look carefully to see some of its original features such as tiles, engraved glass, bar counter and dado panelling. The Crown Tavern claims that Lenin used to drink here while living in the area and might well be where Lenin and Stalin met in the early 1900s.

Station: Farringdon

12. Rookery Hotel, Cowcross Street

The dictionary definition of 'rookery' is of a crowded, dilapidated tenement or group of dwellings existing in slum conditions, and the term is certainly the perfect description of Cowcross Street and its environs during the 1800s. The neighbourhood was a notorious hotbed of vice and crime, with pickpockets and vicious thieves hiding in its alleyways and courts where they would disappear into a maze of small and very narrow thoroughfares. It was an area of great poverty where people lived cheek by jowl, there was no running water, families shared rooms and sanitary conditions were dire. Cowcross Street was always noisy, smelly, full of people and animals and generally an unhealthy place to be. It was

the main route into Smithfield Market where horses, cattle, sheep and pigs came to be slaughtered. The situation slowly began to change in the 1860s when many of the slums were demolished to make way for the construction of the railway and Farringdon Road, and Smithfield itself became a 'dead' meat market, but it took until the late twentieth century before the area became gentrified and its buildings renovated. Then its location, so close to Farringdon station and the City of London, made it the ideal place for companies to relocate and many architectural practices and media enterprises moved their offices here into former warehouses, shops and factories.

In the late 1990s a couple of entrepreneurs (owners of Hazlitt's in Soho) recognising Cowcross Street's charm and attractive location purchased a group of late eighteenth-century houses and shops on the edge of Peter's Lane. These they converted into the thirty-three-bed Rookery Hotel and took great care to retain the building's Georgian history, maintaining the names of the shops once trading here on the building's façade. The hotel's rooms are all very comfortable, but no two are the same. During the restoration works an eye-catching new brick tower with slated spire, bulls' and cows' heads (in reference to the area's past) was added to the rear of the building. It is from the tower's penthouse suite, the Rook's Nest, that hotel guests gain excellent views of St Paul's Cathedral.

Station: Farringdon

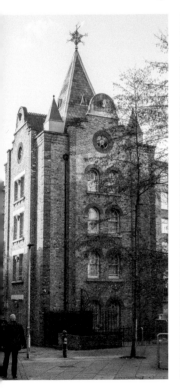 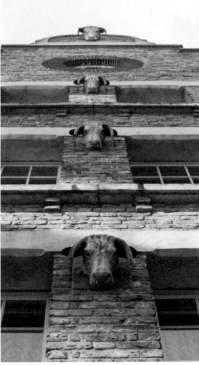 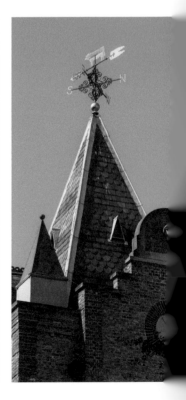

Opposite and above: Rookery Hotel. (© A. McMurdo)

13. Canonbury Square and the Estorick Collection

Many who visit Upper Street fail to wander far from its plethora of shops, cafés and restaurants, so it is unsurprising that Canonbury Square is largely undiscovered. Located behind the Union Chapel (see page **49**) the early nineteenth-century square is a superb oasis with a character of its own. It is composed of imposing brick terraced housing, with much of it between three and five storeys high. Despite the lack of uniformity, the independent terraces possess attractive features such as fanlights, iron railings, balconies and basements.

Unusually, Canonbury Road runs through the centre of the square, thus slicing it and its central gardens in two. The construction of the road in 1812 had an enormous impact on the success of Canonbury Square and led to the bankruptcy of its developer, Henri Leroux. Instead of attracting wealthy residents, in the 1840s the square became home to clerks, teachers, dressmakers and printers and the actor-manager of Sadler's Wells Theatre, Sam Phelps. By the early twentieth century, when the square was looking run-down, the writer Evelyn Waugh (1903–66) took up residence, and in the 1940s George Orwell (1903–50) and his wife Eileen moved into No. 27b. Here Orwell began writing *Nineteen Eighty-Four* and Victory Mansions, the dilapidated house of the book's hero Winston Smith, is said to be based on the square.

Vanessa Bell and Duncan Grant, members of the Bloomsbury Set, lived in the square in the 1950s, by which time it was a slum. During the 1960s and 1970s

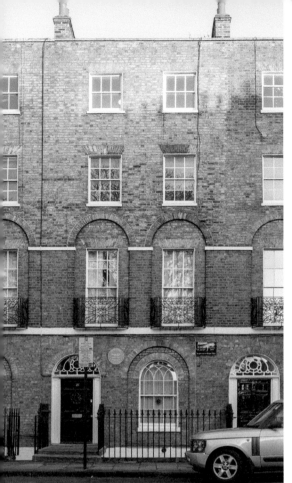

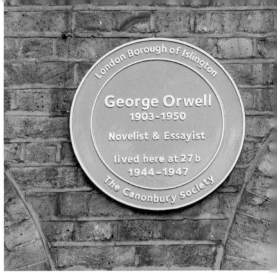

Above: George Orwell's plaque.
(© A. McMurdo)

Left: George Orwell's home in Canonbury
Square. (© A. McMurdo)

Below: The Estorick Collection.
(© A. McMurdo)

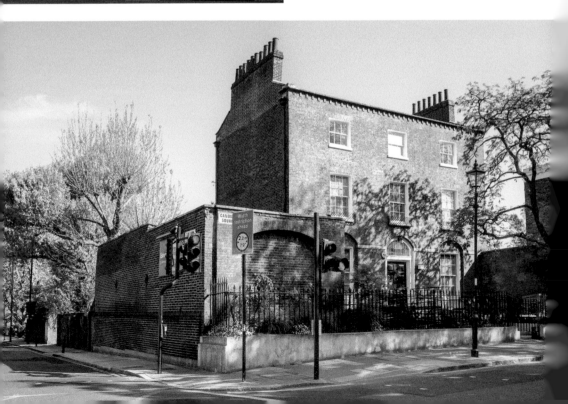

property developers, seeing the square's potential, restored much of the housing stock and it became both attractive and fashionable again. Today, it is certainly one of Islington's most prestigious addresses and houses are sold here for several million pounds.

No. 39, sitting on the corner of Canonbury Road, is now home to the Estorick Collection of Modern Italian Art, formed by Eric and Salome Estorick in the 1950s. Built as a gentleman's villa in the early 1800s, the gallery displays works of the Futurist Italian artists Balla, Boccioni, Carra, Russolo and Severini, as well as those of Modigliani and Morandi, and is certainly worth a visit.

Website: www.estorickcollection.com
Stations: Highbury & Islington, Canonbury

14. Almeida Theatre, Almeida Street

Since 1980 the Almeida Theatre has been hosting and producing plays at its premises on Almeida Street, and it is impossible to miss the striking large white building with its beautiful symmetry and simple exterior. In the past forty years the theatre's reputation has grown considerably and many productions first performed here have subsequently been transferred to London's West End and even Broadway. For many years the Almeida has been staging plays, covering an enormous range of themes and offering classic, contemporary writing as well as international programmes. It is a theatre where producers have not been shy to

Almeida Theatre. (© A. McMurdo)

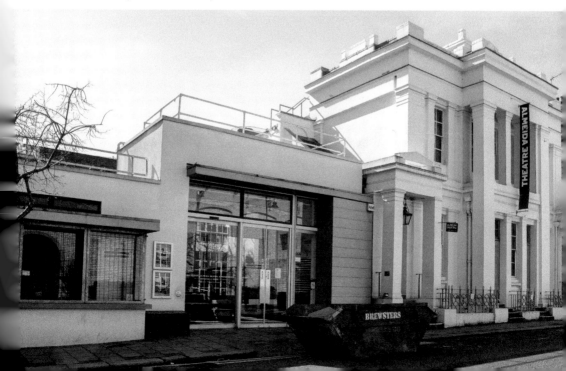

introduce new approaches and have pushed boundaries. Many exciting plays have been produced at the Almeida by highly acclaimed directors and an enormous number of celebrated actors have performed on its stage. A feature of the Almeida is its curved back wall behind the stage. This is said to have greatly contributed to the theatre's success, making audiences feel closer to the performing space and thus with the cast itself.

However, the building did not start out life as a theatre. It was built in 1837 as the home of the Islington Literary and Scientific Institution. Members had access to the institution's library, museum, reading room and laboratory, and lectures were held in its 500-seat auditorium where subjects such as magnetism, music, astronomy and the nervous system were explored. It was here in 1840 that the first Egyptian mummy to arrive in the country was unwrapped. Despite its initial popularity the institution closed in the 1870s and was replaced by the Wellington Club until 1888. It was then acquired by the Salvation Army and known as Wellington Castle barracks. In the mid-1950s the property changed hands again and became the showroom and factory of Beck's Carnival Novelties, which stocked party novelties and disguises and traded throughout the world. By 1971 the building found itself on the market again when the company's manager was battered to death by his stepson. The scandal brought about the demise of the business and the premises then lay empty until converted into the Almeida in the late 1970s.

Website: www.almeida.co.uk
Stations: Angel, Highbury & Islington

15. Lloyd Square and Bethany House, Lloyd Baker Street

Lloyd Square, wedged between Pentonville and King's Cross Road, has a unique charm of its own. Perched on the top of a hill, the square was laid out between 1825 and 1840 and looks distinctly different from Islington's other Georgian squares. In contrast to the tall brick terraces of Canonbury Square (see page 31), the pattern here is for pairs of semi-detached villas adorned with pediments and recessed porches – reminiscent of ancient Greece. The villas surround a central garden, and this, together with the arrangement of the housing, gives Lloyd Square a rural atmosphere that so appealed to its early occupants (surgeons, solicitors and watchmakers). Unsurprisingly, this most pretty and peaceful enclave still continues to attract professionals and middle-class residents.

Overlooking Lloyd Square is Bethany House, built in the 1880s as a House of Retreat for the Sisters of Bethany. It is a particularly imposing Queen Anne building and now holds Grade II listed status on account of its striking features – its high chimneys, gables, parapets and two-tone brickwork. Although originally built as a convent and school, the building was converted into a studio and YWCA

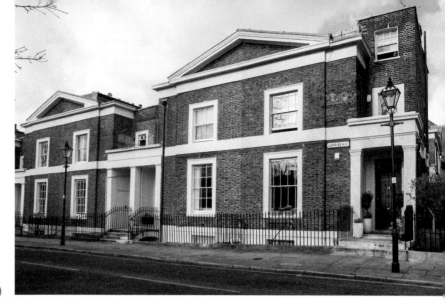

Lloyd Square.
(© A. McMurdo)

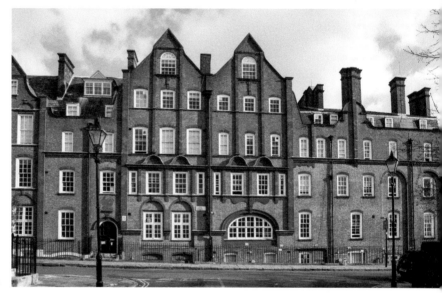

Bethany House.
(© A. McMurdo)

hostel in the 1960s. Nowadays it provides housing and support to vulnerable and homeless women.

Stations: Angel, King's Cross

16. Finsbury Bank for Savings, Sekforde Street

Looking like an Italian Renaissance palace, the former Finsbury Bank for Savings contrasts greatly with the modest yellow-brick terraces to which it is attached along Sekforde Street. Faced in white stucco with outer bays at either end (the public and manager's private entrances) the building is striking not only for its

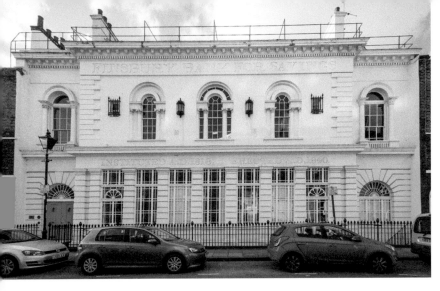

Finsbury Bank
for Savings.
(© A. McMurdo)

size but also its arched windows, pilasters, decorated cornice and prominent fascia sign inscribed 'FINSBURY BANK FOR SAVINGS'.

It was converted into a family residence in the 1990s and today consists of seven bedrooms, has its own wine cellar, vaults and a courtyard as well as a grand curved staircase. When it was built in 1839–40 it contained a 44-foot-long waiting hall; two 30-foot rooms, one a public office, the other a boardroom; and thirteen domestic apartments.

There were no banks in Islington in 1800, but as the area developed the banking system flourished and eleven had been established by 1880. The Finsbury Bank for Savings opened in Clerkenwell in 1816 and was one of the earliest savings banks for the neighbourhood's workers: clockmakers, printers, tradesmen, labourers and servants. It proved to be particularly successful attracting not only poor savers but also more prestigious customers such as the novelist Charles Dickens.

Station: Farringdon

17. Former Royal Free Hospital, Liverpool Road

As with the 'not in my backyard' brigade today, the proposal in the 1840s to build a London Fever Hospital in Liverpool Road was met with great opposition by local residents. Many believed that a fever hospital would put them at major risk of exposure to infectious diseases such as typhoid, scarlet fever and smallpox and felt compelled to call a public meeting in April 1848 to discuss how best to prevent the hospital from going ahead. Nonetheless, permission to develop the site was granted by the authorities and within a year the London Fever Hospital was up and running. Its design, attributed to two well-regarded architects, David Mocatta (1806–82) and Charles Fowler (1792–1867), produced the most handsome of buildings constructed in stone and red brick connected to two wings by colonnades. Looking much like a small stately home the hospital disguised the

fact that it was treating fever patients, many of whom were very poor. In fact, it was common for the rich to pay for their servants to be treated here in order to keep their own families safe.

From the time it opened it functioned as an independent hospital, employing eminent physicians such as the sanitary reformer Thomas Southwood Smith (1788–1861) and the discoverer of the distinction between typhus and typhoid, William Jenner (1815–98). The novelist Charles Dickens (1812–70) was so impressed by the hospital's work that he wrote in his magazine *All The Year Round* that it was 'not only the single hospital of its kind in London but probably the best hospital of its kind in Europe'. With his support, and that of William Wilberforce and Florence Nightingale, the valuable work of the hospital was brought to the

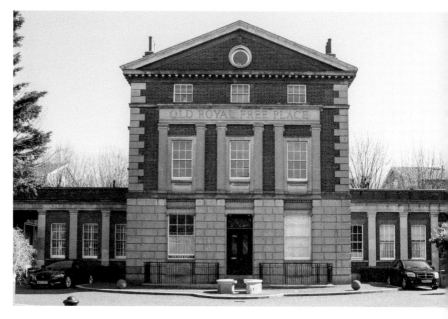

Former Royal Free Hospital. (© A. McMurdo)

public's notice. In time, public health improved, the risk of infectious diseases lessened, and the hospital practised more general medicine. In 1948, it joined the Royal Free Hospital (RFH) and specialised in women's and paediatric care. The hospital finally closed when the RFH moved to Hampstead in 1974 and was later converted into social and sheltered housing, winning several architectural awards for the quality of its redevelopment.

Station: Angel

18. Caledonian Tower and Market, Copenhagen Fields

When the decision was taken in the early 1850s to close the centuries-old livestock market at Smithfield, it was thought that its removal to Copenhagen Fields was the ideal solution as it was an undeveloped site on the outskirts of London. Moreover, it was much larger than Smithfield and able to accommodate both a cattle market and 35,000 sheep pens. Called the Metropolitan Cattle Market, it flourished here for over eighty years until war broke out in 1939. At this point it was forced to close and never reopened. Over its lifetime it was affectionately

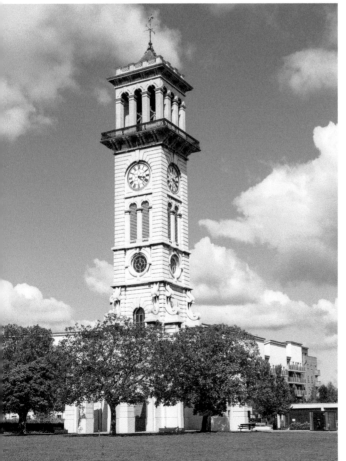

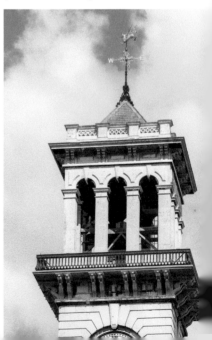

Left and below: Caledonian Tower. (© A. McMurdo)

known as the 'Caledonian Market', famous throughout London for its weekly Friday flea market where people said you could find anything from food and tools to china, clothing and even coffins. Sadly, in the post-war years the market lay derelict until it was finally redeveloped as social housing in the 1960s and the tower was the only structure of the market buildings left standing.

From the time it was erected in 1855 the Caledonian Tower was intended to be seen and was intentionally positioned right in the middle of the Metropolitan Cattle Market. Soaring high above the marketplace, the Italianate tower was always the main focus of the site and was originally surrounded by busy banking and telegraph offices at its base. Designed by James Bunstone Bunning, architect and surveyor to the Corporation of the City of London, the Caledonian Tower remains today as a wonderful example of Victorian civic architecture. Just a quick glance at its structure is sufficient for one to appreciate not only its design but also the quality of materials used – its Portland stone, cast iron and slate. With its pyramidal roof and iron weathervane, attractive windows and prominent clock, it was built to exude grandeur in the livestock market.

Following a recent restoration project the tower now regularly opens for public tours, allowing visitors to climb up the tower passing by its four clock faces on the ascent. Arriving at the viewing balcony (just beneath the bell chamber), one is rewarded by simply stunning views of the London skyline.

Website: www.callypark.london
Station: Caledonian Road

19. Former Royal Agricultural Hall, No. 52 Upper Street

Today No. 52 Upper Street is home to the Business Design Centre (BDC) and is a thriving conference, exhibition and event venue. Sitting high above the main road it is instantly recognisable with its curved glass façade and attracts people from all over the world to trade fairs, food, art and design exhibitions. The BDC has only been operational here since the mid-1980s when, after a long period of neglect, the structure was lovingly restored. This followed a public campaign to save the building when many alternative uses such as a Dickens London theme park, ice-skating rink and housing had been proposed but none were thought to be suitable for the site.

The original hall was built by the Smithfield Club in the early 1860s for its annual agricultural and livestock exhibitions and was known as the Agricultural Hall. It covered an enormous space (larger than either Alexandra or Crystal Palaces) and more than 1,000 tons of cast iron were used in its construction. The hall's wide-spanned vaulted roof was particularly impressive and this, together with its cast-iron gallery and railings, lent it the atmosphere of a Victorian railway station – features that still remain today. By 1885, through royal patronage, the

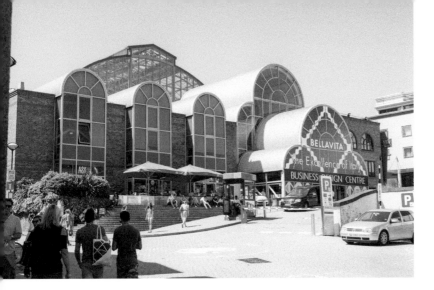

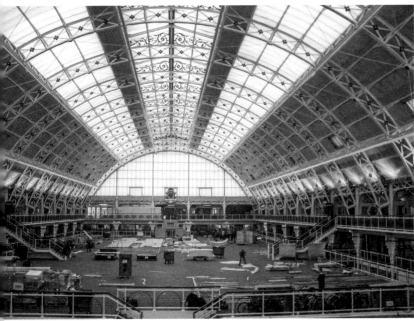

Former Royal
Agricultural Hall.
(© A. McMurdo)

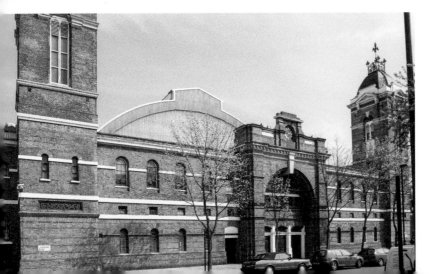

building had become the 'Royal' Agricultural Hall, and affectionately known by the locals as 'The Aggie'. Events staged here were not confined to agriculture alone but included horse shows, walking races and marathons, military tournaments, circuses and even Crufts Dog Show. It attracted people from every class and was considered the place to be seen. Charles Dickens wrote about it and Walter Sickert captured it in art. Even famous politicians like Gladstone and Churchill were seen enjoying themselves here.

During the Second World War it became home to the General Post Office, which occupied the premises until 1971, by which time the Aggie's previous role had been replaced by London's Earl's Court and Olympia Exhibitions Centres and the building went into total decline.

Fortunately, local businessman Sam Morris took up the challenge to return the Aggie to its former grandeur; with a substantial cash injection it was both renovated and transformed into the Business Design Centre.

Website: www.businessdesigncentre.co.uk
Station: Angel

2C. St Peter's Italian Church, No. 136 Clerkenwell Road

St Peter's is London's oldest Italian church. Designed by Irish architect John Miller Bryson and renowned for its Roman basilica style, it was modelled on San Cristogno in Trastevere, Rome. It was specifically built in the 1860s for Clerkenwell's burgeoning Italian community, although it was always intended to be used by Roman Catholics from all nations. The church owes its existence in Clerkenwell to a Europe-wide fundraising campaign, and much of its very beautiful interior is the result of work of Italian builders, designers, artisans and artists who were brought over to embellish and decorate the building following its completion. The interior is particularly celebrated for its high painted ceilings and stunning frescoes, and St Peter's excellent acoustics have resulted in it being the venue for many concerts over the years. In fact, two world-renowned tenors, Enrico Caruso (1873–1921) and Beniamino Gigli (1890–1957) have both performed in the church.

St Peter's is easy to find on the Clerkenwell Road due to its unusually lofty, narrow two-bay frontage and double-arched loggia and its colourful frieze and statues. A flight of stairs takes you to the main entrance where to the left, above a full-length marble war memorial, you see a striking sculpture of a lifeboat containing three figures. The sculpture, by Mancini, was erected in 1960 to commemorate the Italians who, as internee passengers, lost their lives on the liner the *Arandora Star*, which was torpedoed on its way to Canada in 1940.

Every year on the Sunday closest to 16 July a service takes place at St Peter's based around the feast of Our Lady of Carmel (Fiesta di Madonna del Carmine). This is followed by a splendid procession and a fiesta enjoyed by the entire Italian community of London. All traffic is banned from the area during the parade and

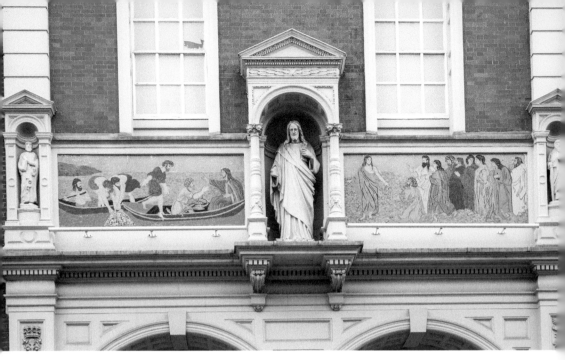

Above and below: St Peter's Italian Church. (© A. McMurdo)

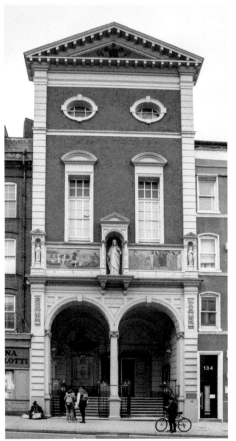

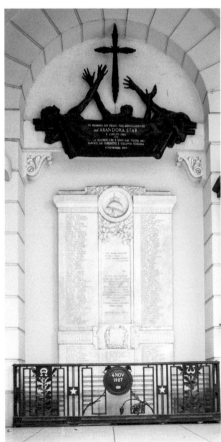

spectators line the pavements to see the multicoloured floats filled with biblical scenes of saints and martyrs making their way through the local streets. In 1883, when the festival began, it was the very first Roman Catholic procession of its kind in London's streets since the Reformation in the sixteenth century.

Website: www.italianchurch.org.uk
Station: Farringdon

21. King's Head Theatre Pub, Upper Street

It is possible that there has been a King's Head pub on this site for several hundred years. The diarist Samuel Pepys (1633–1703) certainly refers to one in his famous diary, but the present pub dates to the 1860s. Full of character, it still displays many original features typical of the Victorian period. Of particular note are the granite Ionic columns and elegant curved windows of its façade and the bar counter and etched glass within.

The theatre was the brainchild of New Yorkers Dan and Joan Crawford and opened in 1970 in a space behind the bar previously used as a boxing ring and pool hall. Their idea was to attract touring companies to perform to small audiences, a little like travelling players did in Shakespearean times, and was the first of its type in the

The King's Head. (© A. McMurdo)

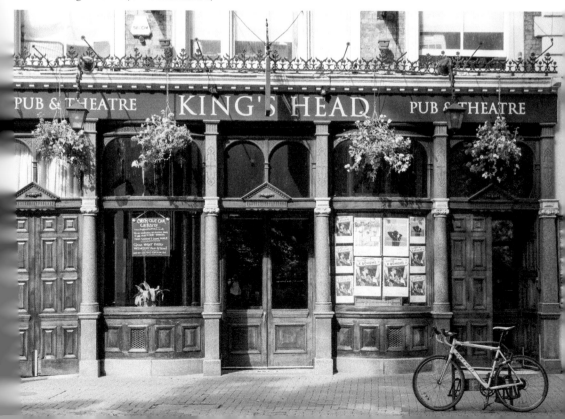

country. A complete departure from the theatre of the time, it introduced the concept of fringe theatre, an alternative experience, and much of it experimental in nature.

As the theatre became more established it put on its own productions and was eager to promote works of unfashionable or little-known playwrights, to stage musicals, comedy and opera. The King's Head theatre was always adventurous, keen to push the boundaries and thus became the breeding ground for new writing, acting or directing talent. Many well-known directors and actors launched their careers at the theatre including Steven Berkoff, Tom Stoppard, Hugh Grant, Alan Rickman and Victoria Wood and many others, including Joanna Lumley, Anthony Sher and John Hurt have performed on its stage. Some productions have won awards while others have been so successful that they later transferred to major theatres on both sides of the Atlantic.

Since 2010 the theatre has concentrated largely on opera (in English translation), its LGBTQ programmes, revivals of post-war plays as well as external and in-house works. Now, having outgrown its fifty-year-old home, it has exciting plans to move to purpose-built premises next door in the basement of No. 116 Upper Street. Here it will have both a 250-seat auditorium and fifty-eight-seat studio and offer its audiences, actors and staff greatly improved facilities.

Website: www.kingsheadtheatrepub.co.uk
Stations: Angel, Highbury & Islington

22. The Castle pub, Nos 33–35 Cowcross Street

The Castle sits right beside Farringdon station where Turnmill Street and Cowcross Street meet. It is one of the area's busiest and most popular pubs, renowned not just for its atmosphere but also for its great selection of craft beers and food. The building, sporting a curved front, is particularly attractive and possesses some splendid windows, decorative brickwork and a pretty cast-iron balustrade.

Until the 1850s Cowcross Street had been the main route into Smithfield Market, London's main meat market, where cattle, sheep and pigs were slaughtered. At that time the area was notorious for its poverty and was home to many petty criminals and low lifes who staged cockfights for entertainment. One evening the Prince of Wales (later George IV) attended a session at nearby Hockley in the Hole. As the prince was gambling and needed more cash he called in at The Castle, where he entrusted the publican with his gold watch as surety for a loan. Later, when the prince returned to pay off his debt, he rewarded the publican with a pawnbroker's licence in gratitude for his help, the sign of which (three gold balls) can still be seen hanging outside the pub today.

Website: www.thecastlefarringdon.co.uk
Station: Farringdon

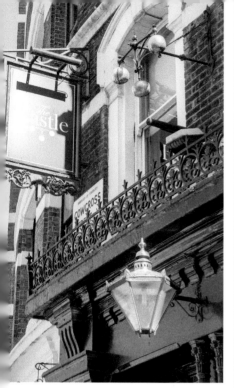

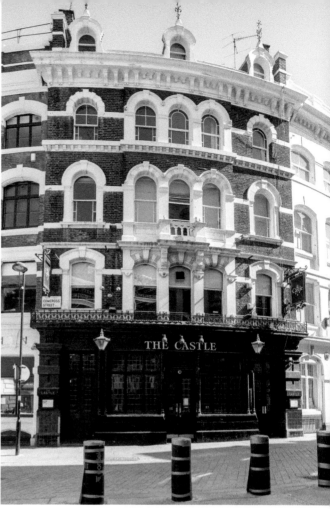

Above and right: The Castle.
(© A. McMurdo)

23. Farmiloe Building, Nos 34–36 St John Street

The Victorians certainly knew how to make industrial buildings look grand! The Farmiloe Building, built in 1868 for glass and lead merchants George Farmiloe & Sons, is a truly magnificent example of their workmanship and design. Passers-by wonder at the building's almost palatial exterior, characterised by its many beautiful windows, imposing keystones, wonderful ornate brickwork and decorated carriage gate. The latter provided the entrance into a large service yard, behind which were warehousing buildings and workshops, while Farmiloe's main showroom was in the main building facing St John Street. The warehouse floors, unusually robust due to the weight of the lead stored there, were believed to be the strongest anywhere in London at the time and still remain a feature of the building. George Farmiloe & Sons continued to operate from these premises until 1999 when it relocated to Surrey.

Since that time location scouts have 'discovered' the site and it has been the set for many films and TV programmes such as *Batman Begins* (2005), *The Dark*

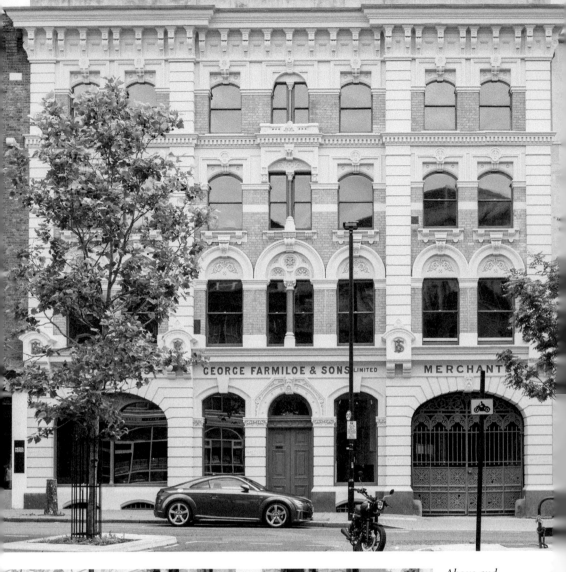

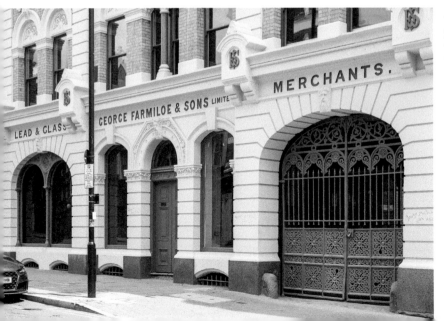

Above and left: Farmiloe Building. (© A. McMurdo)

Knight (2008), *Inception* (2010), *Spooks* (2010) and *Mission: Impossible – Rogue Nation* (2015).

Most recently, after major refurbishment blending old with new, Farmiloes reopened as a high-tech commercial space within this significant landmark building.

Station: Farringdon

24. The Goldsmiths' Centre, No. 42 Britton Street

The Goldsmiths' Company is one of London's oldest trade guilds. Dating back to the Middle Ages, its original function was to protect its customers, employers and employees by monitoring the standard and quality of its products. It is one of the Twelve Great Companies of the City of London and still maintains responsibility for hallmarking precious gold and silver articles. Today it also sponsors students and youngsters entering the industry, encourages excellence in jewellery design and craftsmanship and carries out much charitable work. In the early 2000s the company set up a charity, The Goldsmiths' Centre, to supervise the professional training of goldsmiths, with the centre moving into new purpose-built premises at No. 42 Britton Street in 2012.

Below and oveerleaf: The Goldsmiths' Centre. (© A. McMurdo)

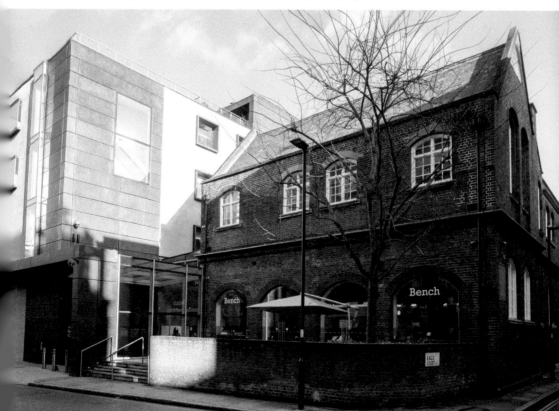

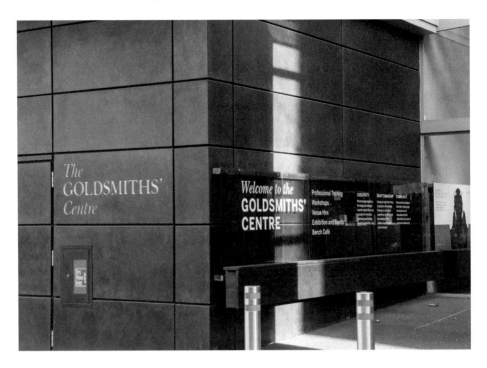

Conveniently located just a stone's throw away from London's jewellery hub in Hatton Garden, the Goldsmiths' Centre combines a late nineteenth-century school with a contemporary twenty-first-century building linked together by a glazed atrium. Lyall Bills & Young LLP, the centre's architects, have managed to create a sense of great harmony between the two buildings even though they are built in entirely different styles and reflect their own age. Great care has been taken in the centre's construction to make it environmentally friendly – it has photo-voltaic cells and there is a roof garden to encourage wildlife. The interior of the centre is remarkably light due to the use of glass and contains a large exhibition space, workshops, studios and seminar rooms as well as offices and a café. The centre provides a facility for those interested in gold and silversmithing to come together and learn more about the craft and offers them reasonably priced workshop space. Training courses concentrating on both technical and business skills are delivered here and cater to many different groups – apprentices, start-ups as well as established businesses – to help people develop their careers. The Goldsmiths' Centre is undoubtedly a unique facility where new industrial recruits benefit by working alongside practising goldsmiths. In such a way the Goldsmiths' Company supports its trade and fulfils its mission 'to advance, maintain and develop art, craft, design and artisan skills related to goldsmithing'.

Website: www.goldsmiths-centre.org
Station: Farringdon

25. Union Chapel, Compton Terrace

Until the early 1800s much of Islington was little more than countryside, having a population of around 10,000. By the end of the century, due to rapid industrialisation, the numbers swelled to more than 200,000, which resulted in the appearance of many new chapels and churches built to meet the spiritual and religious needs of Islington's new residents. The first Union Chapel was set up in Compton Terrace in 1806 and, as its name suggests, welcomed worshippers from all Christian denominations. As time went on the chapel became too small for its sizeable congregation, so the authorities decided to replace it. In 1874 they held a competition for its design, which was won by the Nonconformist church

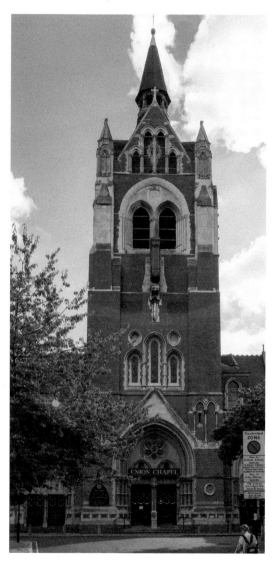

Right and overleaf: Union Chapel.
(© A. McMurdo)

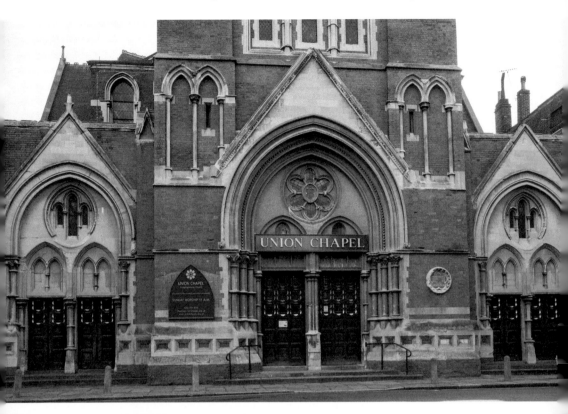

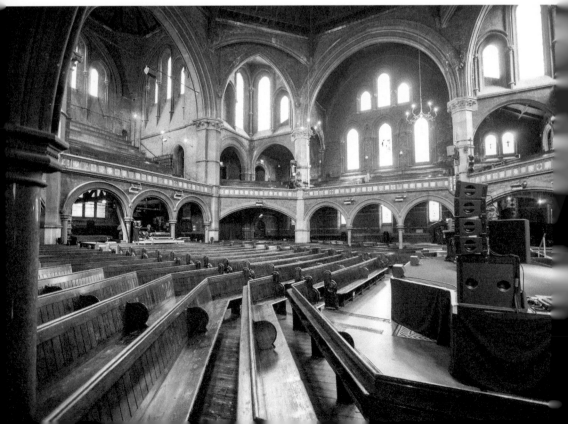

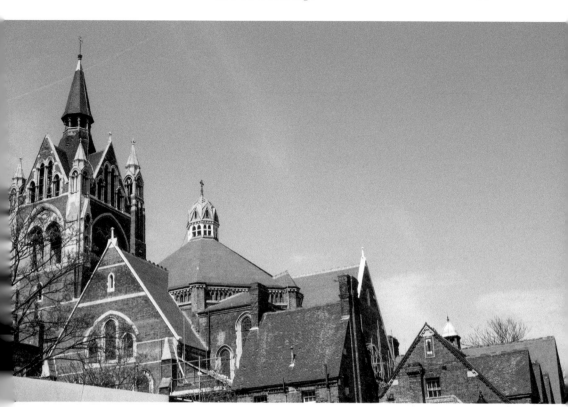

architect James Cubitt (1836–1912) – no relation of, and not to be confused with, Thomas Cubitt who was responsible for building Belgravia, Bloomsbury and Pimlico. Following guidelines provided by the minister and church deacons, Cubitt proposed a plan for a vast octagonal church that would allow all congregants to both see and hear the service free from columns or any obstruction. His imaginative design was considered a masterpiece, cementing his reputation, and Union Chapel remains one of the most outstanding Nonconformist buildings of the Victorian age.

The chapel was not fully complete until its striking red-brick tower (also Cubitt's design) was added in the late 1880s. Victorian Gothic in style, it is especially noted for its octagonal roof, cupola, belfry and lancet windows. Inside, many of the chapel's original features have been preserved, including magnificent pews and the Henry 'Father' Willis organ, whose sound has always filled the church. It is no wonder that Union Chapel is an English Heritage Grade I listed building.

Sadly, by the 1980s church attendances declined so much that only the timely creation of a charity – Friends of the Union Chapel – prevented its demolition. The charity has since worked tirelessly to attract people back into the building – both the chapel and its many spaces have been hired out regularly for gigs and musical events, resulting in it not only becoming a much-loved London venue but ensuring the survival of its celebrated musical tradition.

Website: www.unionchapel.org.uk
Station: Highbury & Islington

26. Peabody Buildings, Pear Tree Court

As the population of Clerkenwell (and much of London) escalated in the 1800s it was obvious that there was an urgent need for more housing. Huge numbers were known to be living in squalor in extremely cramped and damp conditions in old tenement buildings. Fortunately, their plight was recognised by reformers such as Lord Shaftesbury (1801–85), Angela Burdett-Coutts (1814–1906) and Charles Dickens (1812–70) who campaigned vigorously for the introduction of better housing conditions and worked hard to improve the circumstances of the poor and working classes.

They were joined in their struggle by wealthy American financier and merchant George Peabody (1795–1869), who was greatly affected by those he saw in extreme poverty on London's streets. He donated half a million pounds to provide clean, well-ventilated and healthy accommodation for the capital's respectable, poor working classes – tailors, shop assistants, needlewomen, warehousemen,

Peabody Buildings, Pear Tree Court. (© A. McMurdo)

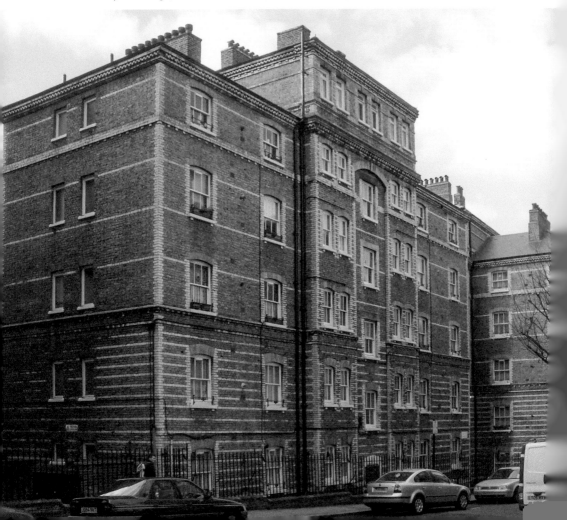

printers and constables, who earned meagre but stable salaries. In 1862 he created a trust to fund this innovative social housing and the buildings he pioneered still remain, distinctive due to their size, common layout and use of yellow stock brick.

Pear Tree Court in Clerkenwell, looking much like other Peabody housing, was erected in 1884. It followed the well-established layout of Peabody's architect, Henry Darbishire, namely a group of five-storey accommodation blocks around a central court. Tenants were carefully vetted, all had to be vaccinated against smallpox and they were subject to strict rules involving the cleaning of communal passages and lavatories. They paid a reasonable rent and greatly appreciated the facilities on hand such as shared laundries on the top floors and safe play areas for the children.

Peabody was really a legend in his own lifetime, and he received much acclaim for his work. So much so that on his death in 1869 he was given a state funeral and buried in Westminster Abbey, the service attended by the monarch, Queen Victoria. However, the terms of his will requested he be laid to rest in his home town of Danvers, Massachusetts, and his body was later exhumed and returned to America. Today, his name lives on with many residing in affordable London Peabody housing.

Station: Farringdon

27. Church of Our Most Holy Redeemer, Clerkenwell

The Holy Redeemer, Clerkenwell, was designed in the Italian basilica style of Brunelleschi's Church of Santo Spirito in Florence by the English church architect John Dando Sedding (1838–91) and completed after his early death by his assistant, Henry Wilson (1864–1934). Sedding wanted the church, completed in 1888, to be built in a manner 'stately and impressive, uplifting the minds and hearts of those who dwelt beneath its shadow'. The end result is surely testament to his objectives. English Heritage describes the church to be 'of outstanding importance as an example of the late nineteenth century reaction against High Victorian Gothic' and awarded it Grade II* listed status. Certainly, Holy Redeemer's design conforms to the pure Italian Renaissance style and it has both the feel and appearance of a Roman Catholic Church. Its exterior, with its outstanding campanile, stands out in Exmouth Market. Likewise, the interior of the church, with its colonnades of massive Corinthian columns, its free-standing Baldacchino high altar and Father Willis organ, is impressive. The church still operates in the Anglo-Catholic tradition and is famous for its choral music.

Prior to the building of Holy Redeemer, from the late eighteenth century the site had been home to a series of Nonconformist chapels including the Methodist Connection, belonging to the wealthy Selina, Countess of Huntingdon. Earlier in the 1700s it had been a popular teahouse. Known as the Pantheon, providing

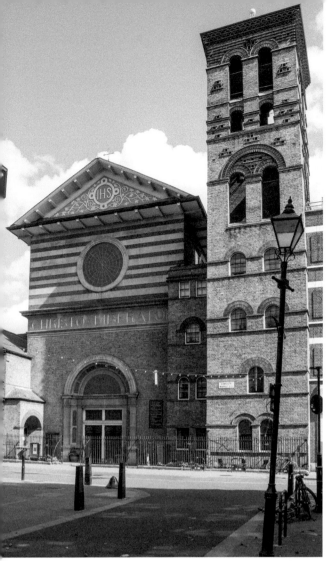

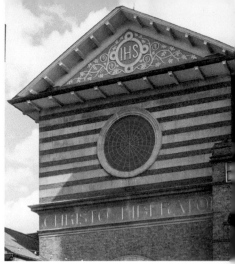

Above and left: Church of
Our Most Holy Redeemer.
(© A. McMurdo)

'Tea and Spiritous Liquors', it was a humbler replica of the much larger Pantheon in Oxford Street, which had been built for the aristocracy. The building was round with two internal galleries that extended around the entire building and outside there were beautiful spacious gardens with walks, shrubs and fruit trees, a large pond and generous seating. Sadly, the behaviour of its clientele (mainly journeymen tailors, hairdressers, milliners, mantua makers and service maids) was often too boisterous and upset the authorities sufficiently that they closed down the venue in 1776.

Interestingly, the area behind today's church was a plague pit in the seventeenth century. It then became a cemetery before its recent transformation into a popular local park, Spa Fields.

Website: holyredeemerclerkenwell.com
Station: Farringdon

28. Former Islington Chapel, Nos 311–312 Upper Street

You can be in no doubt as to when the chapel was built as the date '1888' is prominently inscribed on the gable above its grand and picturesque oriel window. It is a most handsome building in the Queen Anne style, characterised both by its warm red brick and stone dressings, and by its attractive cupola and clay-tiled roof. It also boasts some excellent ironwork around the windows, railings and entrance gates, created by the local St Pancras Iron Work Company. The original chapel contained seating for 1,000, had an upper gallery and an organ made by Henry Speechly & Sons, which still remains in situ. The chapel's design and features were clearly influenced by R. Norman Shaw (1831–1912), a proponent of the Arts and Crafts movement.

Islington Chapel closed in 1979 and was converted into a music complex, the Angel Recording Studios. For forty years it successfully attracted A-list clients from all over the industry and globe. Celebrated orchestras, film and TV score composers, bands and individual artists have all used its facilities, but a change in

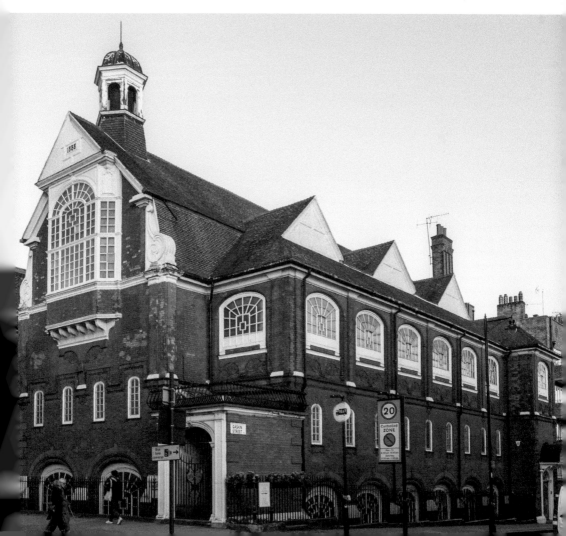

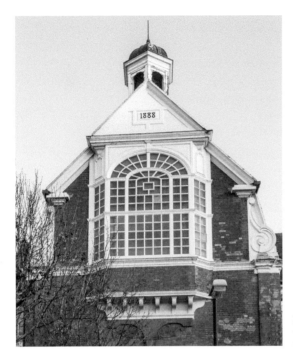

Left and previous page:
Former Islington Chapel.
(© A. McMurdo)

circumstances has recently forced the studios to close, and for the time being the future of the beautiful Grade II listed building is uncertain.

Stations: Angel, Highbury & Islington

29. Former Hugh Myddelton School and the House of Detention, Sans Walk

When Hugh Myddelton School was built in 1892 it was one of London's largest board schools, catering for 2,000 children and renowned for its separate centre for deaf pupils. The school closed in 1971 and almost thirty years later was converted into luxury accommodation, now known as Kingsway Place. The school buildings, conspicuous on account of their height, beautiful red and yellow brickwork and use of terracotta and stone are complemented by ornate stone panels and moulded heads. Much of the perimeter wall that surrounds them dates back several hundred years and was placed here at a time when it was the site of two prisons.

The first of these, the Clerkenwell Bridewell, opened in 1615 to cope with the overload from the City of London's prisons and in the 1680s a holding prison, the New Prison, was built nearby. In time the convicted prisoners were transferred to other local gaols, the former buildings were demolished, and a replacement prison, the Middlesex House of Detention, was built to deal solely with those

Above, below and overleaf: Former Hugh Myddelton School and the House of Detention. (© A. McMurdo)

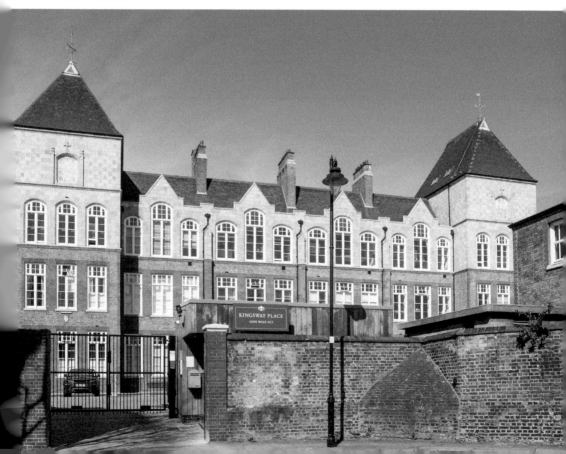

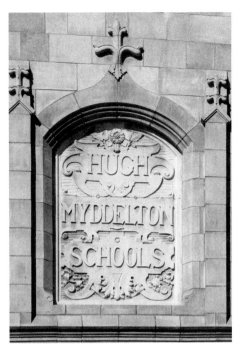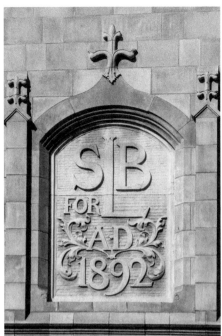

awaiting trial. More than 10,000 people passed across its threshold each year and it became London's busiest prison. Life here was harsh and prisoners subject to many regulations: they had to clean their own cells, remain silent and were forbidden to sing, whistle or shout in the buildings, cells or yards. They received daily rations of food, but the amount given depended upon the prisoner's gender, age and length of stay in the prison. In 1867 the prison suffered a shocking, though unsuccessful, bomb attack to free Burke and Casey, two Irish Republican prisoners. Michael Barrett, found guilty of plotting the explosion, was ultimately the last man to be publicly hanged in England in 1868.

When the prison closed in 1889 its basement, full of original prison cells, was one of few parts of the building to be incorporated into the new school buildings. During the Second World War the cells and basement tunnels were used as air-raid shelters, and more recently, in the 1990s, they became a spooky tourist attraction, bringing to life the building's grim and penal past.

Stations: Farringdon, Angel

30. City, University of London, Northampton Square

It is interesting that Islington's very own university began life as the Northampton Institute as long ago as 1894. It received its royal charter in 1966, at which time it became known as The City University London, reflecting its long association

with the City of London and the livery companies. More recently the university joined the University of London, adopting the name 'City, University of London' (CUL), but remains a self-governing autonomous body with its own senate, council and student union. CUL is a thriving centre of learning today, spread over a number of buildings in and around St John Street and Northampton Square. The original red-brick and stone building faces St John Street and was designed in 1896 by E. W. Mountford, the architect of the Old Bailey. With turrets, cupola, lantern tower and large clock the building has a real presence on the street and is a wonderful example of baroque architecture. Its many windows, ornate wrought-iron gates and the marvellous figure frieze above the main doorway are some of the building's greatest features. Look up above the first-floor windows and you will also discover a series of panels with sculptures portraying technology.

The original institute was founded with the aim of promoting 'the industrial skill, general knowledge, health and wellbeing of young men and women belonging to the poorer classes' and offered courses mainly relating to science and engineering, horology and artistic crafts for industry. An impressive 125 years on and CUL is still very much associated with maths, computers and engineering, but now also has business, law, health sciences, and arts and social science schools, with a student body of 20,000. City is still the only London institution to offer a BSc in Optometry and is a major centre for those training to become journalists. Many of its past alumni now work in the media, legal profession, politics, finance

Below and overleaf: City, University of London. (© A. McMurdo)

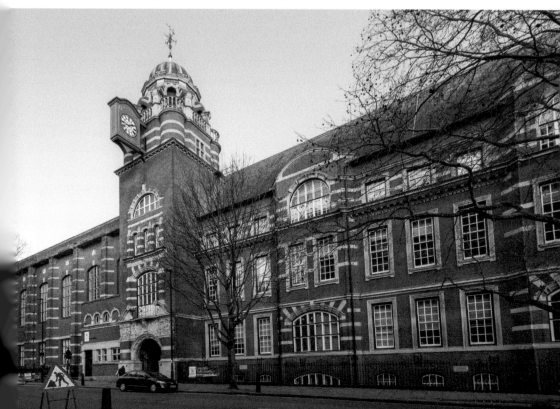

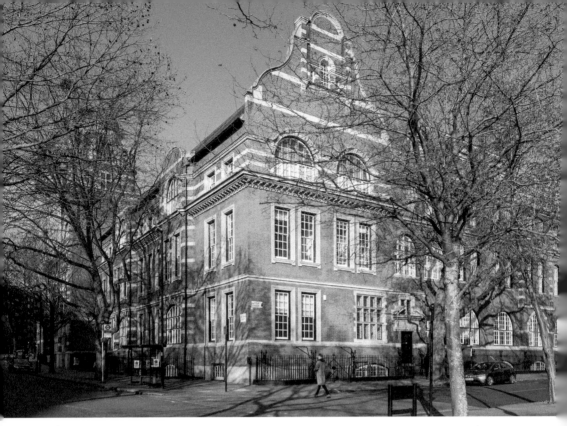

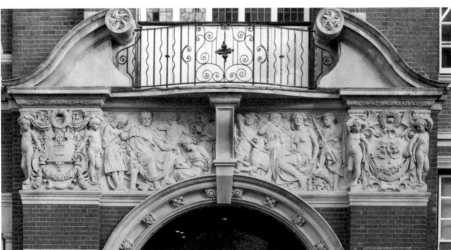

or have become entrepreneurs. Included in their number are ex-Prime Minister Margaret Thatcher, Stelios Haji-Iannou, Clement Atlee, Gandhi and Nehru.

City's former swimming pool and Great Hall were both competition venues used in the 1908 London Olympic Games.

Website: www.city.ac.uk
Stations: Farringdon, Angel

31. Finsbury Town Hall (now The Old Finsbury Town Hall), Rosebery Avenue

Islington's former Town Hall was miraculously given a new lease of life in the early 2000s when the Covent Garden-based performing arts school Urdang Academy decided to relocate here. By 2007 the building, which had previously been so dilapidated that it was included in English Heritage's 'List of Buildings at Risk', had been both lovingly restored and adapted for its new use with the creation of a number of performance spaces, dance studios and singing rooms. Many of these spaces are now hired out and are in regular use by West End shows for rehearsals and auditioning. They are also available for corporate events, private functions, weddings and filming, with the profits generated from these activities going towards bursaries for Urdang Academy's promising trainees.

The building was designed by Charles Evans-Vaughan in 1895 and occupies a large triangular plot encompassing Rosebery Avenue, Rosoman Street and Garnault Place. One glance at its flamboyant exterior characterised by lofty chimneys, ironwork, pillars and ornate roof decoration confirms its grandeur. It may be that Evans-Vaughan was inspired by the work of E. W. Mountford,

Below and overleaf: The Old Finsbury Town Hall. (© A. McMurdo)

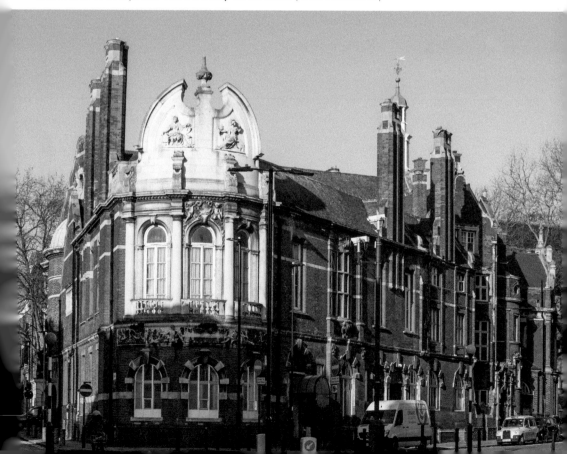

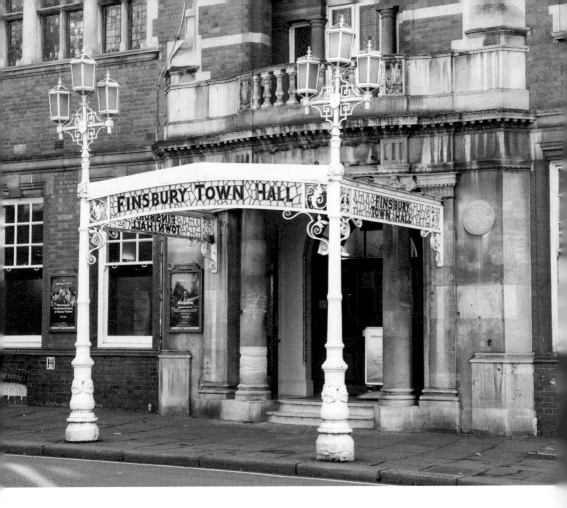

whose Northampton Institute (see page 58) has similar qualities and was built around this time. Certainly, the building's glass and wrought-iron entrance canopy is quite magnificent. Designed in the art nouveau style, it is complemented by slim pillars, elegant triple lanterns and decorative leadwork with the inscription 'FINSBURY TOWN HALL'. The building's style has been described as 'Free Flemish' with art deco, art nouveau and baroque influences, the latter demonstrated by the carved frieze above the first floor where Garnault Place and Rosoman Street meet.

The interior is elaborate too, with a sweeping staircase and very beautiful stained glass. Perhaps the building's piece de resistance is the Great Hall, which has seen a new lease of life since Urdang's renovation. It is once again the most opulent of rooms, boasting some excellent art nouveau details. Not only do Urdang students perform here but the hall is a popular venue for banquets and wedding celebrations. Hardly surprising considering the stunning setting with its sumptuous furnishings, barrel-vaulted ceiling and baroque-influenced angels lining the walls.

Stations: Farringdon, Angel

32. Collin's Music Hall (now Waterstones), Islington Green

The attractive Regency-style building facing Islington Green is nowadays home to Waterstones bookshop. However, between 1862 and 1958 the site was the location of a very famous entertainments venue, Collins Music Hall, that in its heyday attracted many well-known names including Charlie Chaplin, George Robey, Marie Lloyd, Gracie Fields and Kate Carney. It was also where Tommy Cooper, Tommy Trinder, Benny Hill and Norman Wisdom kicked off their careers. Sadly, today nothing remains of the former music hall. The only reminder of its colourful past is a plaque on the wall above Waterstones' entrance canopy.

The site's association with the entertainment industry dates back to the 1790s when it operated as the Lansdowne Tavern. Like many similar establishments of the time, it introduced a singing room where its customers sang along with the performing artistes. By the middle of the nineteenth century the singing room had become a music hall, built behind the main public house. In 1862 former chimney sweep-turned-actor Sam Vagg (1825–65) saw Lansdowne Tavern's potential and purchased the building. He lent his stage name, Sam Collins, to his enterprise and Collins Music Hall was born with seating for 1,000. It was a great success, and despite Sam's death in 1865 the music hall continued, playing to large audiences daily. Performances could last several hours, consisting of around twenty different acts covering anything from opera to ballet, trapeze,

Waterstones. (© A. McMurdo)

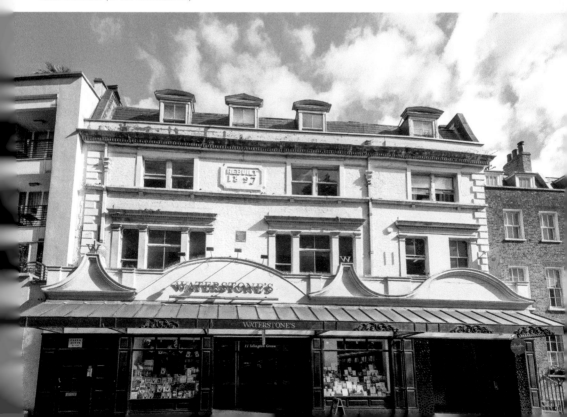

conjuring, singing and storytelling. The music hall survived both world wars, but by the 1950s its appeal waned as television became popular and Collins became a strip joint. This didn't last long, however, as a devastating fire gutted much of the premises in 1958, forcing it to close. Fortunately, some of the playbills and signed photographs of former artistes were saved and were auctioned off by Tommy Trinder in 1963.

In 2008 the construction of a theatre was begun in Waterstones' basement, but it was never completed and remains a shell. When – or if – the project will go ahead is far from certain, but it seems fitting that the site should once again be used as an entertainment hub.

Station: Angel

33. The Fox & Anchor, No. 115 Charterhouse Street

Tucked away in a small street leading to Charterhouse Square, the Fox & Anchor is one of Islington's hidden gems, resplendent in art nouveau tiling and sporting artistic panels, cut glass and gargoyles on its most original and distinctive façade.

The pub was designed by architect Latham Augustus Withall (1853–1925), but the remarkable frontage owes its design to fine art designer William J. Neatby

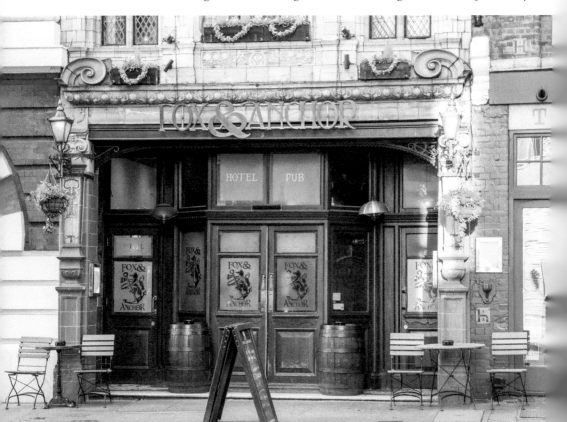

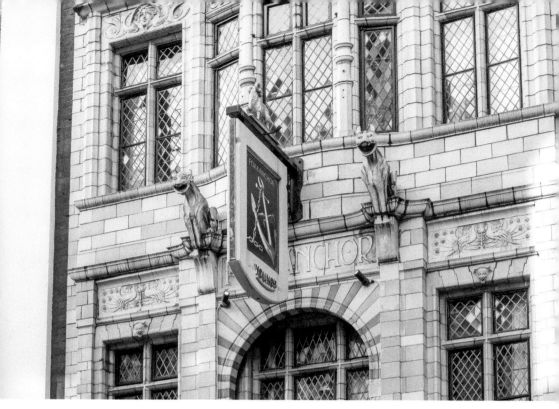

Opposite, above and right: The Fox & Anchor. (© A. McMurdo)

(1860–1910), largely acclaimed for his magnificent interior of Harrods Food Hall. The present building was constructed in 1898 and has always been a favourite with workers from nearby Smithfield Market – opening early morning to provide food and sustenance to the market porters at the end of their working day, though in the twenty-first century it is more likely to attract stockbrokers on their way to work in the City.

Nowadays it is run by Young's brewery as a gastropub and boutique hotel. The interior is extremely atmospheric with wood panelling, a long bar, wood and etched-glass partitions and a fabulous, embossed plaster ceiling. Upstairs there are six luxurious, comfortable bedrooms, each decorated in its own style.

The Fox & Anchor opens daily and is famed for its Market Cuts, Sunday roasts and City Boy Breakfasts.

Website: www.foxandanchor.com
Station: Farringdon

34. Booth's Gin Friezes, No. 24 Britton Street

It is easy to walk along Britton Street and unknowingly pass by these fascinating wall reliefs as they are fixed high on the second floor of Mountford House, just beneath its decorated cornice. The frieze and the granite arches at ground level were originally part of the Turnmill Street frontage to Booth's Distillery Ltd offices (based in the parallel road). When these premises were demolished in the early 1970s, the decision was taken to re-erect the five art panels here as a reminder of the key role that Booths and the gin industry had played in the area since the 1700s. The Portland stone panels, designed by F. W. Pomeroy for the 'Cow Cross Distillery' (as it was then called), charmingly illustrate the different stages in the gin-making process – from the cutting of the grain to the placement of the spirit in barrels for distribution.

Booth's along with J&W Nicholson & Co., Gordon's, Tanqueray and Langdale's all established gin distilleries in Clerkenwell's streets in the eighteenth and nineteenth centuries. They were attracted here because of the district's abundant supply of fresh water – the very same springs that had drawn the monks and nuns to settle in the neighbourhood in the Middle Ages. These distillers, through the introduction of new production methods, produced a much higher quality spirit than had previously been available and established not only their reputations but also laid the grounds for a better managed distilling industry.

Prior to this time London had been in the grip of 'Gin Mania', when gin was distilled in people's homes and sold everywhere at rock-bottom prices. Not only was it made from inferior grain, but to give the gin more taste the unscrupulous distillers added sawdust and turpentine to it. Many of London's poor were totally addicted to the spirit and it was the cause of enormous drunkenness,

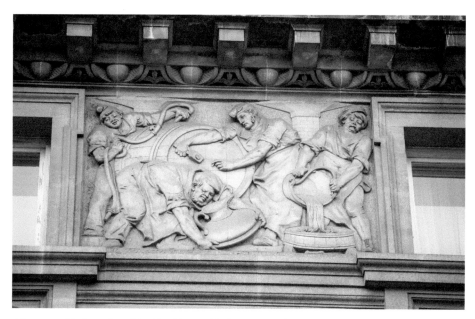

Above and below: Booth's Gin friezes. (© A. McMurdo)

crime, debauchery and death, best summed up by the slogan, 'Drunk for a penny, dead drunk for tuppence' and captured in William Hogarth's satirical engraving *Gin Lane*. It was only after the passing of legislation in the 1750s curbing cheap gin production that the situation improved, and London Dry Gin was developed.

Station: Farringdon

35. The Angel, Islington

Within striking distance of both the City of London and the West End, the area fondly known as 'Angel' has been a major hub for hundreds of years. It is conveniently located at an intersection on the main route from the north into London and was where, from the Middle Ages, drovers and shepherds stopped to fatten up their cattle and sheep before herding them for slaughter at Smithfield Market. Until the industrialisation of Islington in the 1800s this part of London was still a rural retreat, a place of recreation where nobility came to hunt, practice archery and strolled in the meadows and forest. A sizeable coaching inn known as The Angel was built here in the 1680s, replacing an earlier one on the site. Before long it had earned itself a reputation for staging plays and became very popular

Below and opposite: The Angel, Islington. (© A. McMurdo)

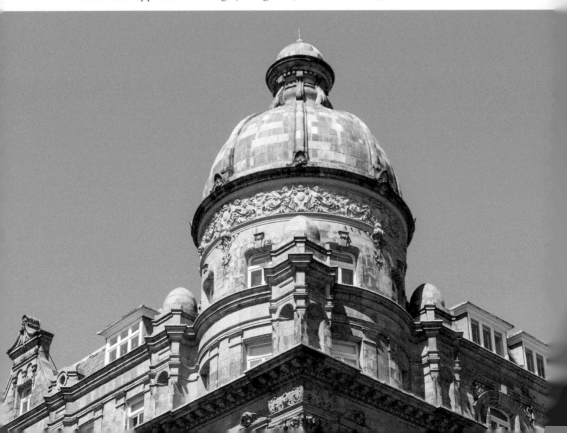

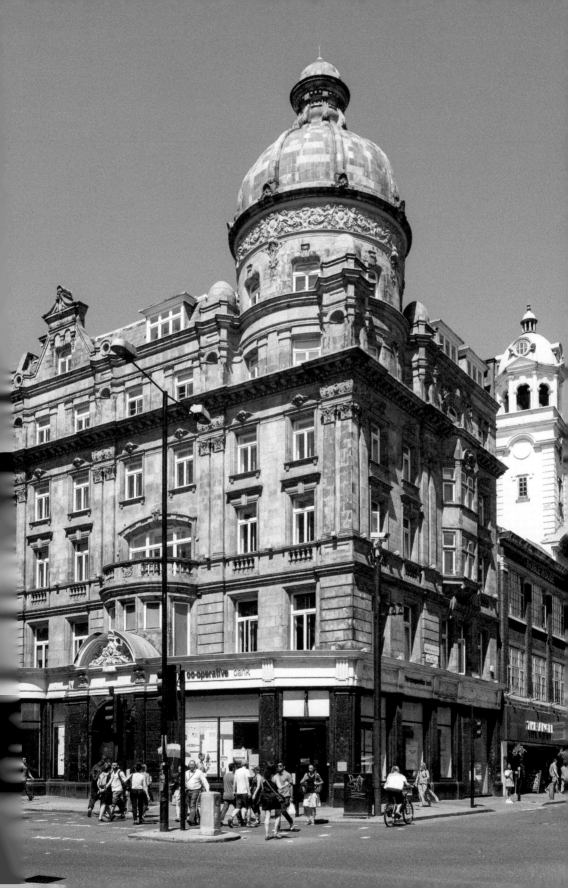

with its customers, who would stand along its upper double gallery and in the coachyard below to watch the performance. As they entered the yard customers placed money into a box, and once the play had begun it would be removed to an office away from the entertainment. This became known as the 'Box Office' and is possibly the derivation of the modern term.

The Angel was immortalised in Willliam Hogarth's engraving *The Stage Coach* (1747) and throughout its lifetime was one of Islington's best-loved inns. It appeared in Charles Dickens' books *Barnaby Rudge* and *Nicholas Nickleby* and also featured in Thomas Hughes' *Tom Brown's School Days'*.

Over the course of the nineteenth century the inn underwent several reincarnations, and in 1899 its famous cupola was added – still the building's most prominent feature. By now the Angel was sitting beside a junction of five roads and saw more than 4,000 passengers travelling past it daily. The inn finally ceased trade in 1921, became a tearoom for some years and later a bank, which it remains today.

Remarkably, in the 1930s when the district was shabby and run-down, 'The Angel, Islington' was actually included on the Monopoly board (albeit one of the cheapest sites), a tribute to its past and confirmation of its significance to the London scene.

Station: Angel

36. Northern District Post Office, Nos 116–118 Upper Street (now Islington Square)

The former District Post Office located opposite St Mary's Church (see page 23) is a superb illustration of how the Edwardians, like the Victorians before them, took pride in their civic architecture. The building was opened in 1906 and received instant acclaim. It was admired not just for its symmetry, height, warm red brick and white stone, but also for its delicate Ionic columns and group of four graceful caryatids, the latter supporting a balcony poised as the centrepiece of the building's façade. The post office fronting Upper Street was part of a substantial mail complex containing an enormous sorting office as well as an engineering building to the rear housing the London Test Salon, the General Post Office (GPO) Stores and GPO Factories division. From the outset it was a major employer in Islington (more than 3,000 worked here in the early twentieth century), and it was common for entire families – mothers, fathers, aunts, uncles, grandparents, cousins and siblings – to work on the premises in a variety of jobs. In the 1960s when British Telecommunications was formed telecommunications research was carried out here too.

However, in the early 2000s the decision was taken to close down the sorting office, relocate the post office and to redevelop the site into 'Islington Square',

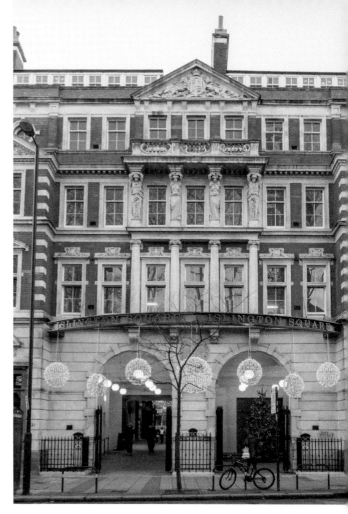

Right and below: Islington Square.
(© A. McMurdo)

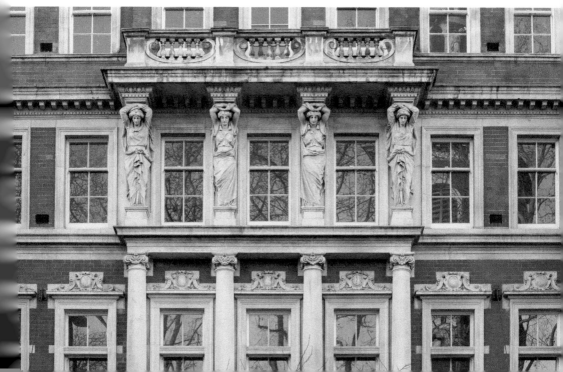

a retail, leisure and accommodation centre. As the post office was a Grade II listed building consent was needed from the local authority and English Heritage before any alterations or demolition of existing buildings could be carried out and planning permission approved.

Islington Square finally opened in 2019 and despite modernisation of the buildings behind Upper Street its excellent Edwardian frontage was retained. Not only has the development established an entire new neighbourhood consisting of a public piazza, shops, a cinema and health club, but it has also built 263 new homes. Some of these are located in the former engineering building while others are located in a new build designed by local architect Piers Gough. Islington Square, linked via two arcades to Upper Street, has been tastefully developed and demonstrates the care taken by its designers to merge its historic character with the new.

Website: www.islingtonsquare.com
Stations: Angel, Highbury & Islington

37. Camden Passage

Although a tiny enclave, Camden Passage is largely accredited with Islington's rejuvenation in the 1960s. Its then newly formed antiques market attracted large numbers of local and UK visitors as well as many from overseas, which in turn led to renewed interest in the area. So much so that speculators were encouraged to buy and spruce up the old, somewhat dilapidated eighteenth- and nineteenth-century properties in the surrounding streets and squares, gradually regentrifying the entire district. As Islington's fortunes improved Camden Passage filled up with antique shops and emporiums as well as original boutique-style shops specialising in vintage clothing and niche items. When Frederick's Restaurant opened in the late 1960s it became an instant success and brought even more people to the area, ensuring the Angel as the 'in' place to visit. Fifty years on and Camden Passage is still exciting to visit – it is quaint with some delightful terraced houses dating to the mid-1700s that display ground-floor shopfronts of a time gone by, but the emphasis has altered slightly. A few antique shops survive and there are weekly antique market days, but now Camden Passage is probably more associated with specialist food shops (especially cheese, coffee and fish), an array of cafés and brunch venues, chic boutiques and jewellery shops. At its Essex Road end is the Camden Head pub, a typical tavern of the Victorian age, with a circular bar, etched glass, partitions and original mirrors. Outside there is a large terrace while daily comedy shows are staged by the Angel Comedy Club in the pub's upstairs room.

Camden Passage remains one of Islington's hidden gems tucked behind the hustle and bustle of Upper Street. Right beside it, on Islington High Street, is an

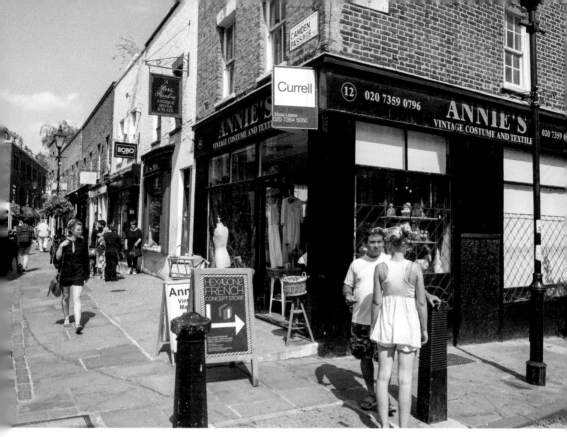

Above: Camden Passage. (© A. McMurdo)

Below: The Mall. (© A. McMurdo)

unusual shed-like building that bears a similarity to George Dance's eighteenth-century Newgate Gaol in the City of London. Initially built as an electricity transformer station and tram depot, it became derelict in the 1960s when trams were replaced by buses. Since then it has been used as premises for an antiques market, a restaurant, a couple of clothing stores and more recently the furniture store Sofa.

Stations: Angel, Essex Road

38. Diespeker Wharf, Graham Road

This is not just one of Islington's most picturesque spots but also a wonderful illustration of its industrial heritage. Originally built as a timber mill, Diespeker Wharf's striking brick building with its tall chimney and modern glass extension today contains the offices of Pollard Thomas Edwards Architects (PTE) who were responsible for both its restoration and conversion in the mid-1990s.

It is hard to imagine now the extent of activity that took place here a century ago. The Regent's Canal was built between 1812 and 1820, and until the railways were established in the 1840s it was the major form of transport used to move goods and materials from one side of London to another. The canal extended from Paddington in the west to Limehouse in the east and barges laden with coal, timber, sand, gravel, metals, corn, ice and refuse would regularly travel along its waters unloading their goods onto the many canal-side wharves. Diespeker Wharf sits beside the lock at the City Road Basin and was in the heart of a thriving industrial area consisting of warehouses, factories and depots until the transport of goods moved away from the canals in the 1960s.

The main mill building is thought to have been built around the late 1890s and its surviving crane, now sitting proudly in the courtyard, would have been used to load and unload timber from the vessels. From 1926 the building was occupied by Diespeker, an Italian terrazzo manufacturer. The company, founded by Italian artisan Luigi Oderico, set up a number of offices and manufacturing plants in cities and towns around the country. Oderico was one of the first to bring the craft of mosaic and terrazzo to the UK and was also responsible for the subsequent training of many British craftsmen. It was Diespeker that introduced reinforced precast terrazzo, which later became such a versatile commercial material, and the company's terrazzo was used to decorate many buildings including Selfridges' staircases.

PTE's tasteful renovation of the Wharf and surrounding buildings have retained not only its Victorian character but have also blended old with the new to great effect.

Station: Angel

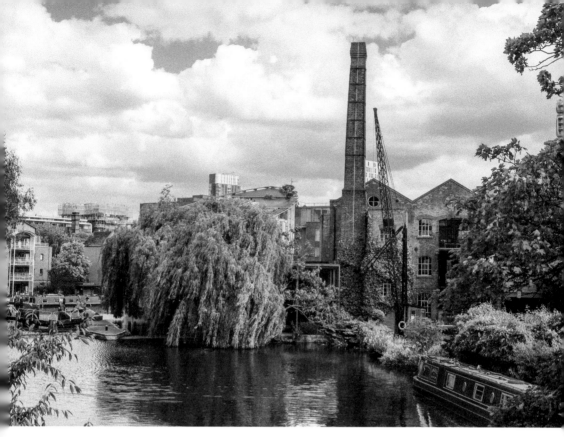

Above and below: Diespeker Wharf. (© A. McMurdo)

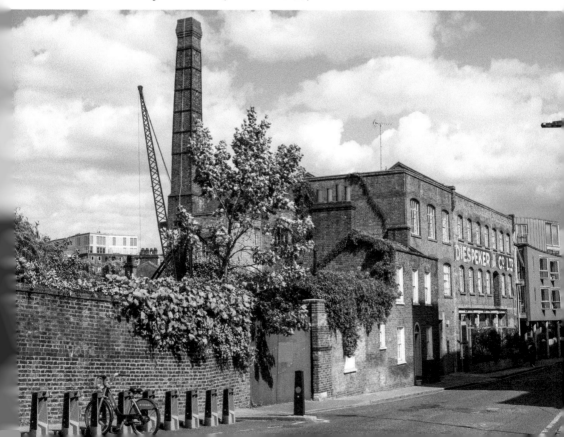

39. The Screen on the Green, No. 83 Upper Street

The Screen on the Green, so identifiable on account of its barrel-vaulted roof and neon-lit façade, is one of Upper Street's most iconic buildings. Despite many alterations to the cinema since it was built in 1913, it still retains its original working red curtain. From 1910 the site was occupied by a small cinema-shop run by the Pesaresi brothers. It was so popular that they decided to buy and demolish the premises on either side of the shop and replace them all with a purpose-built venue. Much larger than the Pesaresi's previous enterprise, the new cinema had seating for 600 in a long, fairly plain hall, and became known as the Empress Picture Theatre. This was a time when electric cinemas showing silent movies were becoming very popular (following the Cinematograph Act of 1909) and before 1914 there were at least four or five in existence and competing for business around Upper Street. Sadly, none have survived today except Screen on the Green, although you can see the domed façade of the former Electric Theatre at No. 75 Upper Street.

By the late 1930s the Empress, although it was cheap and remained popular, seemed dated and shabby and compared poorly with the much more luxurious, vast picture palaces that were being built and showing the new 'talkie' pictures.

The Screen on the Green. (© A. McMurdo)

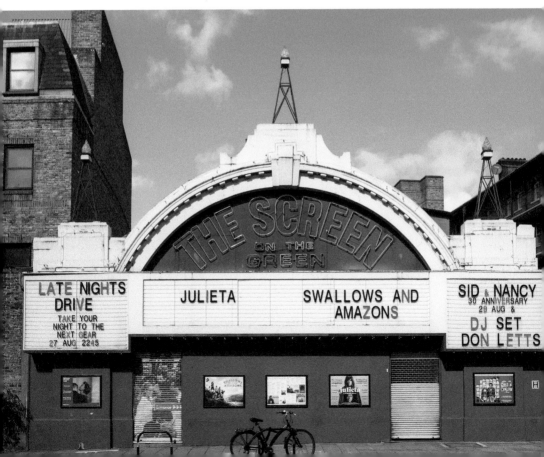

So, in the aftermath of the Second World War the building underwent a major refurbishment and reopened as The Rex in 1951. Twenty years on the cinema changed hands again, now opening as The Screen On The Green. It underwent total renovation in 1981 when it gained its first foyer and the seating was reduced to 300. Perhaps one of its best-known events was in 1976 when Screen On The Green staged a concert featuring The Clash, Sex Pistols and Buzzcocks.

Since 2009 the cinema has been named Everyman Screen on the Green. With plush seating, a bar, state-of-the-art visuals and sound, and a wide range of films encompassing mainstream, arthouse and classic genres it provides a good alternative to the multiscreen complexes elsewhere in Islington and continues to provide an excellent cinema experience.

Website: www.everymancinema.com
Stations: Angel, Highbury & Islington

40. Farringdon Station and Crossrail, Cowcross Street

In January 1863 Farringdon station opened as part of the world's very first underground, the Metropolitan Railway. The persistent and persuasive arguments of a City solicitor, Charles Pearson, convinced the City Corporation to support the project and laid the basis for London's subsequent Underground network and for others around the world. On its first day over 600 passengers travelled the 3.5-mile route between Paddington and Farringdon and then sat down to a banquet at the station to celebrate the marvellous feat of engineering.

Below and overleaf: Farringdon station. (© A. McMurdo)

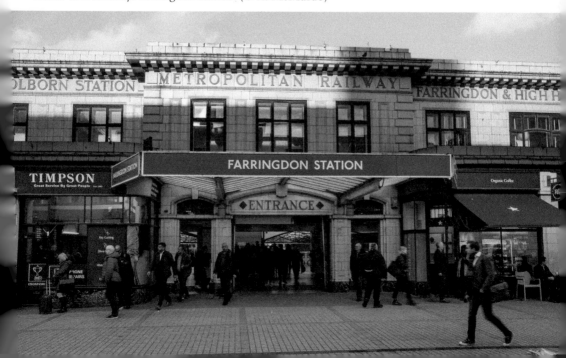

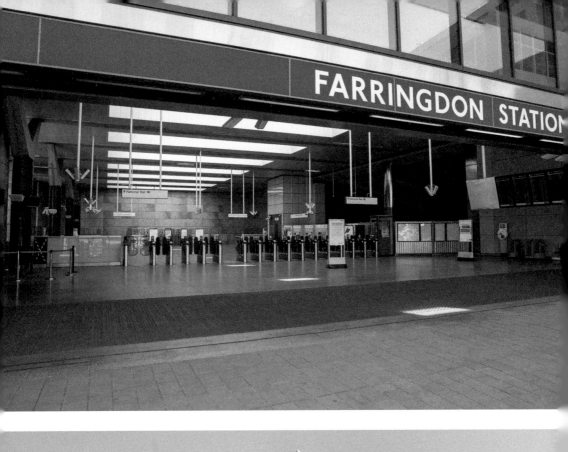

The railway proved to be an immediate success, carrying over 9 million passengers in its first year of operation. Most of its route was constructed using the 'cut and cover' method, which involved excavating a 10- by 6-metre-deep trench from ground level, reinforcing the sides with brick arches and then rebuilding the road on top. The benefits, despite enormous disruption to the surrounding areas during construction, were immeasurable and London's streets soon became less congested. As the early trains were steam-powered locomotives, tunnels were punctuated with regular ventilation shafts to allow the steam to escape, but smoke and fumes remained a problem until rail electrification in 1905.

Farringdon Underground station was rebuilt in 1922 when it was given a new front and name: Farringdon & High Holborn. Although nowadays it is simply 'Farringdon', its former name still stands proudly above its entrance in distinctive lettering. Mainline Farringdon station sits directly opposite the Underground station, operating services between Bedford and Brighton, and services Luton and Gatwick airports. When the Crossrail service, the Elizabeth line, opens here it will transport passengers laterally across London, stopping at Heathrow en route. So, Farringdon will become even busier, a major London hub offering passengers access to three of London's five airports as well as to several Underground lines.

To cope with Farringdon's projected increased passenger flow, a new station entrance was recently constructed beside Charterhouse Square. Here, in the course of excavation, archaeologists discovered twenty-five skeletons and have since established that the corpses were victims of the 1348–50 plague (the Black Death), thus solving a 660-year-old mystery of Farringdon's lost burial ground.

Station: Farringdon

41. Islington Town Hall, Upper Street

The Town Hall, with its wide Portland stone frontage, is certainly an imposing civic building, and possibly stands out all the more for being set back from the main road. Built between 1922 and 1925, it was constructed in stages; the first part to the south faces Richmond Grove, while the north side fronting Upper Street contains the building's main entrance and was added in 1925. The entrance, reached by a flight of steps, has been the backdrop for many a wedding since then and is instantly recognised by Islington Council's coat of arms, which decorates the pediment above the porch.

The Town Hall was built in the aftermath of the First World War when money was in short supply, so constructed on a meagre budget. Nevertheless, its exterior displays interesting classical features as demonstrated by its large and graceful Corinthian pilasters, windows and granite base. The art deco-style interior is more opulent, with a marble staircase and double-height entrance hall and retains many

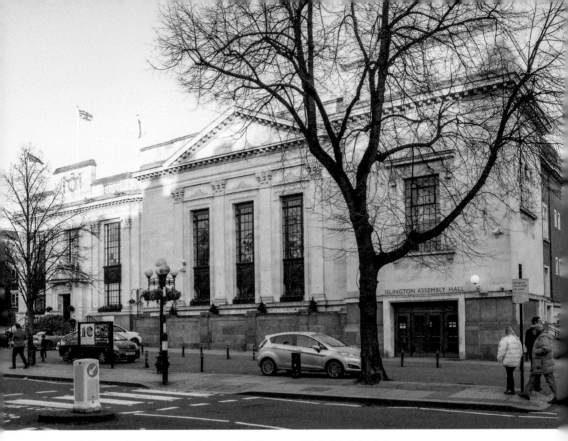

Islington Town Hall and Assembly Rooms. (© A. McMurdo)

original features. Its delightful round central skylight and stained-glass windows allow an immense amount of light to filter through the hallway. The first floor is filled with committee rooms and the magnificent Council Chamber. The latter is octagonal and richly decorated with Diocletian windows, wood panelling, roundel reliefs and carved fixed-pew seating. Naturally, it has been the setting for many marriage ceremonies.

The Richmond Room, another popular wedding venue, sports beautiful oak panelling, original bronze chandeliers and sconces and has an array of semi-domed, moulded ceiling panels. Today, the Town Hall hires out rooms both within this building and in the adjacent Assembly Rooms. The latter has always been a local community centre and still displays some of its original wonderful art deco details. Although today it is known best for live music acts, it has hosted tea dances, variety shows and awards ceremonies throughout its existence.

For almost a hundred years Islington Town Hall has been the location for political rallies and festivities – huge celebratory parades have taken place outside the building following Arsenal victories and it remains a major focal point in the borough.

Stations: Angel, Highbury & Islington

42. The Carlton, Nos 161–169 Essex Road (now Gracepoint)

What a surprising building to discover in the heart of Islington! It appears almost like an Egyptian temple, with columns, lotus flowers and bud reliefs – all reminiscent of items found in Tutankhamen's tomb in the early 1920s.

The Carlton was built as a super-cinema and opened in 1930 with seating for more than 2,000. Like many similar elaborate cinemas of the time its façade was full of colour and ornamentation, yet the sides were plain and made of brick. Built in the art deco style with Egyptian and Empire themes, it is an outstanding example of cinema architecture of the period, and owes its design to the theatre designer George Coles (1884–1963). He was extremely prolific in the 1930s and 1940s and many of his cinemas, like the Gaumont State in Kilburn, still exist though some have since disappeared or are in different usage today.

Until the 1970s the Carlton functioned successfully as a cine-variety venue but a decline in popularity led to it becoming a bingo hall between 1972 and 2007.

Below and overleaf: Former Carlton Cinema. (© A. McMurdo)

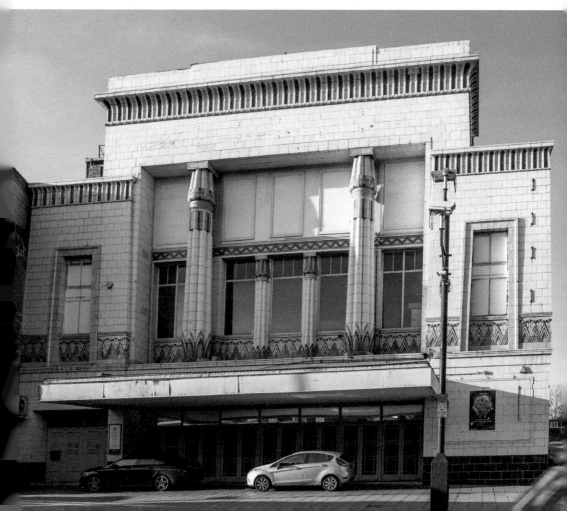

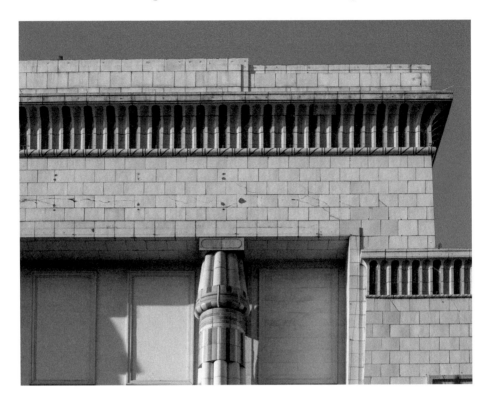

A recent refurbishment has seen its interior transformed and today it is run by a local church, Gracepoint, and the former cinema now doubles as an events venue and religious centre.

Station: Essex Road, Angel

43. Florin Court, Nos 6–9 Charterhouse Square

For anyone who has watched LWT's television series *Agatha Christie's Poirot* (1989–2013) this building, home to Poirot, the great Belgian detective, will undoubtedly seem very familiar. Although during filming the exterior bore the fictitious name 'Whitehaven Mansions', its actual title is Florin Court. During the course of the programme's long run many scenes were shot externally and within the apartment block, allowing viewers to see close up some of its wonderful art deco and modernist details including signs, railings, lighting and interior bannisters.

Florin Court is ten storeys high and was constructed in the mid-1930s, when the art deco and modernist styles were at their height. Unlike the Carlton cinema (see page 81), the building's façade is not swathed in colour, patterns or Egyptian motifs but stands out for its wonderful undulating shape, projecting wings and

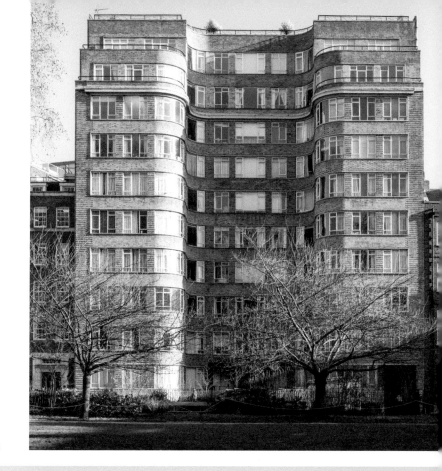

Right and below:
Florin Court.
(© A. McMurdo)

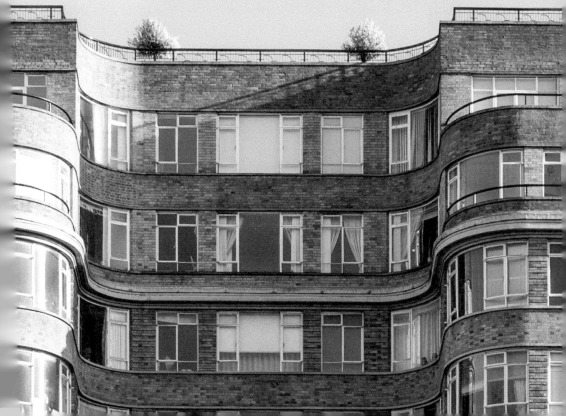

metal casement windows following the building's graceful curves. It was designed by Guy Morgan, who had previously worked for Sir Edwin Lutyens, and is an excellent example of his streamlined moderne style. The block, costing £74,000, was constructed in 1936 and purposely designed as a 'U' shape so that as many flats as possible would have views over the square. The architects worked on the premise that many of the units would be used as pieds-a-terre for those working at nearby Smithfield Market, so some were built as compact studio apartments while others were one- and two-bed apartments. All the flats benefited from the block's facilities: there was a public restaurant, cocktail bar, clubroom and garage in the basement, with squash courts to the rear of the building. Although some of these were lost in the 1980s refurbishment, today residents have access to a basement swimming pool, sauna, gym, lounge room, laundry room and a roof garden.

Unsurprisingly, the flats are highly sought after and quickly snapped up when they appear on the market. In 2013 fire broke out in a first-floor flat, badly damaging the apartment block, but careful restoration has returned the building to its former impressive state.

Pennyworth, the prequel to *Batman*, has recently been filmed around Florin Court and Charterhouse Square.

Stations: Barbican, Farringdon

44. Finsbury Health Centre and Berthold Lubetkin, Pine Street

Finsbury Health Centre was considered to be one of the most innovative and modern medical practices in the country when it was built in the mid-1930s. At the time the district was exceptionally poor, many lived in overcrowded slums and suffered from tuberculosis and a host of other diseases. The National Health Service (NHS) had not yet been established and Finsbury's residents had a life expectancy of only fifty-nine years. Finsbury Council, working alongside the Russian émigré architect Berthold Lubetkin (1901–90) and his Tecton group published the 'Finsbury Plan', a revolutionary proposal to wholly revamp the borough's health, welfare, housing and social needs. Lubetkin's vision was to create a health centre offering a multitude of services under one roof where patients would benefit from a wide range of centralised facilities. Such an integrated clinic was just the second of its kind in London and was highly praised for the breadth of its amenities and for its design. The former included a tuberculosis clinic, chiropodist, de-lousing station, treatment rooms, a reception and waiting room and even an area for families whose homes were being de-infested. The building, designed in the shape of an 'H', consisted of a central core with two angled wings that looked like a welcoming pair of arms. The treatment rooms and clinics were placed in the wings that contained movable partitions to allow for flexibility and large windows, ensuring that the maximum amount of daylight filled the building.

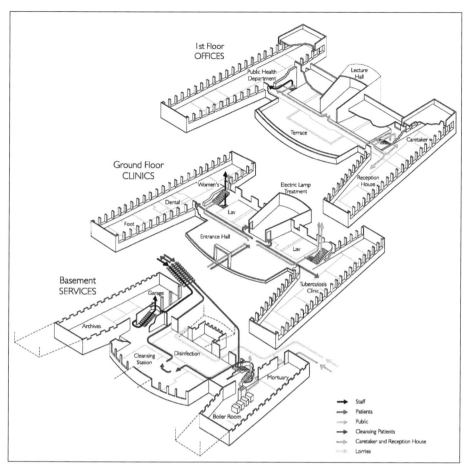

1st Floor
OFFICES

Public Health
Department

Lecture
Hall

Terrace

Caretaker

Ground Floor
CLINICS

Women's

Reception
House

Dental

Electric Lamp
Treatment

Foot

Lav

Entrance Hall

Lav

Basement
SERVICES

Garage

Tuberculosis
Clinic

Archives

Cleansing
Station

Disinfection

Mortuary

Boiler Room

Staff
Patients
Public
Cleansing Patients
Caretaker and Reception House
Lorries

Above: Finsbury Health Centre. Axonometric diagram showing access routes. (Survey of London/Bartlett School of Architecture, UCL)

Below: Finsbury Health Centre. (© A. McMurdo)

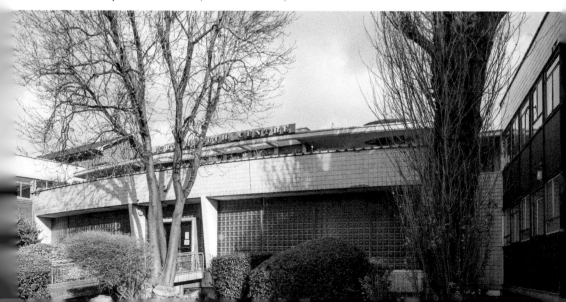

By the early 2000s the fabric of the building was in dire need of attention and proposals were put forward to close it down. Fortunately, due to massive resistance by the local community and the centre's medical staff the plans were abandoned, allowing Lubetkin's masterpiece, the iconic Grade I listed health centre, to continue serving local residents in the way it had done for over eighty years.

Finsbury Health Centre's design certainly remains a testament to Lubetkin's socialist beliefs and philosophy. Further examples in the borough of his distinctive and progressive modernist style can be found in his designs of post-war housing at the Spa Green estate and Bevin Court.

Stations: Farringdon, Angel

45. London Metropolitan Archives, Northampton Road (former Temple Press)

The London Metropolitan Archives (LMA), hidden away in Clerkenwell, holds some of the most interesting and important documents about the capital city. With records dating back to 1067 it is possible, using the LMA's resources, to chart much of London's development and to discover information about local neighbourhoods, family history, buildings, architecture and engineering projects.

London Metropolitan Archives. (© A. McMurdo)

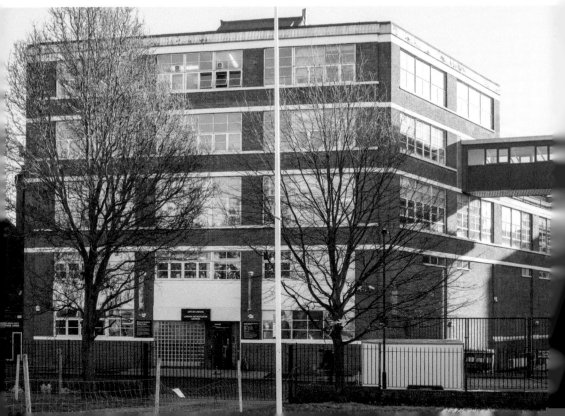

A wealth of documents, maps, images, books and films are held in its many collections, providing fascinating data about London's social, economic and religious history as well as that of the justice and legal system. Since 2005 it has also housed the archives of the Corporation of the City of London, which contain official records relating to the governance of the City, the City of London Police and key London markets. It is the City of London that today administers and funds the LMA and its coat of arms is prominently displayed outside the archives' entrance.

The building occupied by the LMA dates to the late 1930s and was originally built as a printing and binding works for the Temple Press, a company dealing in technical and specialist journals. Built on a concrete frame, it is a substantial building characterised by its industrial, bulky appearance, but perhaps lacks the style and design of some other contemporary buildings in the area.

Temple Press vacated the building in the 1960s and it was the LMA's predecessor, the Greater London Record Office, that moved here in 1982 once the lower storeys of the printing works had been converted. The rest of the building was then turned into office space and became known as the Finsbury Business Centre. In 1992 an extension was erected to house the LMA's 10 linear miles of archival storage, connected to the former printworks by a high walkway. Today, visits are free to the LMA, which apart from being the main local government archive servicing Greater London, is also the largest county record office in the UK.

The building may seem familiar as a number of television programmes, including *Who Do You Think You Are*, *Timewatch*, *Prime Suspect* and *Waking the Dead*, have been filmed here.

Website: www.cityoflondon.gov.uk
Stations: Farringdon, Angel

46. Gibson Square

Gibson Square was the first of two squares to be built on the Milner-Gibson estate in the 1830s and was designed by Francis Edwards (1784–1857), a pupil of Sir John Soane. Constructed as a rectangle with a central garden, it is lined with terraced housing three to four storeys high. Mostly uniform in style, the houses have flat fronts, basements, railings, fanlights and balconies. However, the central houses on the square's east and west sides are unusually embellished with delicate pilasters and a pediment that gives them a definite air of grandeur. The first occupants were largely tradesmen and professionals, but in time the houses became tenanted with single rooms let out by absentee landlords. It was only in the mid-twentieth century that Gibson Square was rediscovered by the middle classes and gentrified.

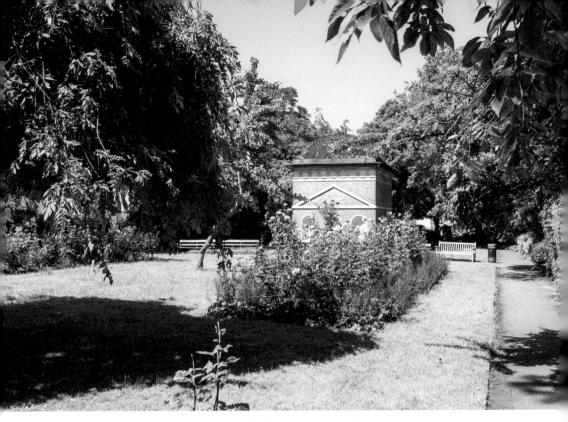

Above: Gibson Square ventilator shaft. (© A. McMurdo)

Below: Gibson Square. (© A. McMurdo)

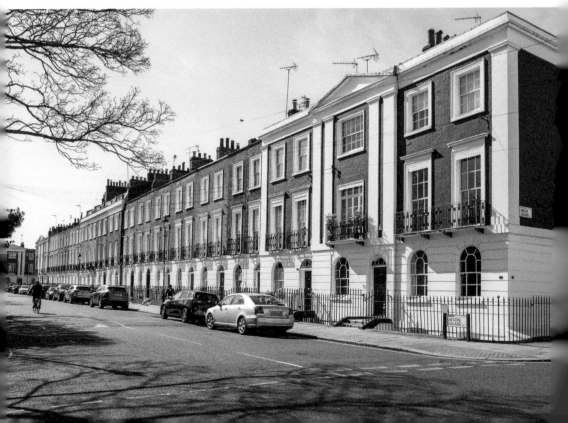

Now a highly sought-after address, the square contains a most unexpected feature in its central gardens – a classical-styled brick 'temple'. Built to complement its Georgian surroundings, it is actually a ventilation shaft for Victoria Line Underground trains running beneath the square. London Underground originally proposed a concrete structure that met with such strong local opposition that the architect Quinlan Terry (b. 1937) was commissioned to design a more suitable alternative.

Stations: Angel, Highbury & Islington

47. No. 44 Britton Street

No. 44 Britton Street with its vivid, blue-tiled roof, angled frontage and overlaid metal frameworks is certainly unique in a street that is largely Georgian in atmosphere. Passers-by stop and stare at this extraordinary townhouse, which some say bears similarity to a prow of a ship, and gaze in wonderment both at its unusual shape and features. Built in 1987–88 as a personal commission for the media broadcaster and journalist Janet Street-Porter CBE (b. 1946), it was designed by her friend and architect Piers Gough, founder partner of CZWG Architects. The house was created through the collaboration of these two and built by Mike Di Marco (they had all studied together at the Architectural Association in the mid-1960s) and is to quote Historic England 'an extrovert and ostentatious example of Post-Modern domestic architecture'. Full of playful features, it is an honest reflection of the highly individualistic personality of Janet Street-Porter and demonstrates her resistance to conformity in all things. There is no apparent front door (it is hidden round the side on Albion Place), the façade is made up of four different shades of bricks that graduate upwards from brown to buff, and the house has a large number of leaded windows, specifically included to give it a fortified air, thus deterring unwanted visitors. Street-Porter insisted that her work and living quarters be kept separate, so Gough cleverly built a self-contained roof office, accessible solely via an external staircase, so she had to go outside to go to work.

The interior of the house is highly unconventional too, and each floor is unique in terms of its layout and decoration. Street-Porter's original interiors included a highly coloured curved staircase, industrial-looking metal mesh walling, and a bath fed by a standpipe. In the fifteen years she lived there she also created a stunning roof garden, a mini-jungle and green, leafy terraces.

In 2018 the house was awarded Grade II listing in recognition of its exciting postmodernist style, and for the way that both the idiosyncratic lifestyle of its patron and inventiveness of its architect had been so well articulated in its design.

Station: Farringdon

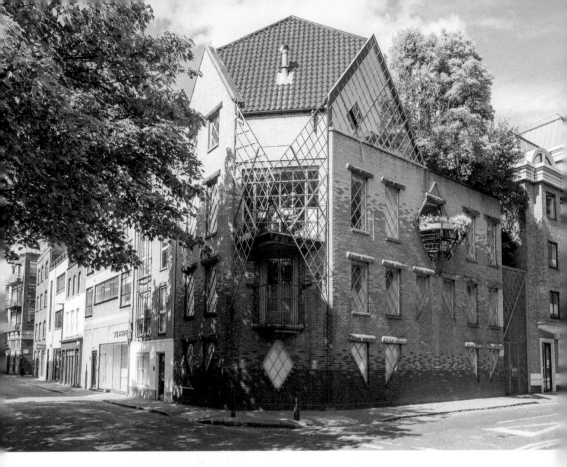

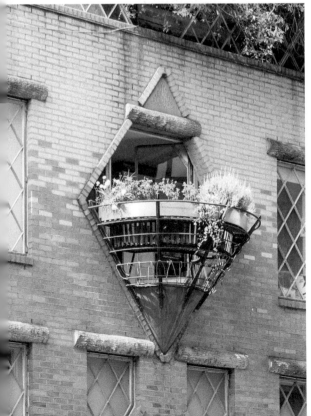

Above and left: No. 44 Britton Street.
(© A. McMurdo)

48. Sadler's Wells Theatre, Rosebery Avenue

With a history of entertainment stretching back over 300 years, Sadler's Wells Theatre in Rosebery Avenue has always been a popular performance venue. Today, the theatre is largely involved with dance – traditional, classic and contemporary – as well as music, movement and opera. It is particularly noted for wonderful performances of Spanish flamenco dancing, Chinese dance theatre, circus acts and Peking Opera, many of which are staged by visiting companies. The theatre regularly stages the somewhat unusual and dark performances of the famous choreographer Matthew Bourne, and also supports and presents new works. It is considered by its many fans to be one of London's greatest performance venues. Since the present theatre opened in 1998 its audiences have delighted in the state-of-the-art auditorium, its sound system, comfortable seating and excellent range of facilities. The newly built Lilian Baylis studio theatre has become very popular too for smaller, intimate productions.

Sadler's Wells Theatre. (© A. McMurdo)

Sadler's Wells derives its name from its first owner, Richard Sadler, who built a 'music' house in 1683 beside a well – which still exists today deep beneath the theatre. By the late 1700s the theatre staged a great variety of acts including tightrope walks, rope dancers, pantomimes, feats of strongmen, singers and even clowns. In fact, it was here that the 'father of clowns', Joey Grimaldi, made his debut at the tender age of three and continued to perform at Sadler's Wells for most of his life. During the mid-1800s, under the management of Samuel Phelps, the theatre concentrated on Shakespearean productions, but following his retirement the theatre found use as a skating rink, boxing venue and a cinema before finally closing down in the early 1900s. Theatrical producer Lilian Baylis worked tirelessly in the interwar years to raise funding for the theatre to be rebuilt. The new theatre, opening in 1931, received great praise for the quality of its drama, opera and ballet productions, engaging the most celebrated actors, dancers and singers of the day. Ultimately the ballet and opera companies left Sadler's Wells and later formed the Royal Ballet and Royal Opera companies in London's West End.

Website: www.sadlerswells.com
Stations: Angel, Farringdon

49. Kurt Geiger Headquarters, Britton Street

The luxury footwear brand Kurt Geiger is acknowledged globally for its bold styles, making it not just a leader in footwear design but at the very forefront of fashion too. The company has been a pillar of London's fashion scene since 1963 when it opened its Bond Street shop and is loved for its designer shoes and accessories, worn by people throughout the world, including many celebrities. With a presence in more than 250 stores, including Harrods and Selfridges, it has established an enormous international customer base and is now Europe's principal luxury footwear retailer, selling more than 4 million pairs of shoes each year.

Kurt Geiger, named after the brand's Austrian founder, has always had its main base in London. It moved into its Clerkenwell headquarters in 2009, a former 1970s office building that had suffered greatly from overheating and a lack of natural light. Through clever design, Archer Architects, commissioned to upgrade the building, introduced a new entrance pavilion and atrium, allowing light to stream into the building especially down to the lower floors. Externally, a new brise-soleil was added in bright 'Pompeian red', providing welcome shade to the building and more importantly establishing a fabulous new iconic exterior.

Station: Farringdon

Kurt Geiger headquarters. (© A. McMurdo)

50. No. 15 Clerkenwell Close

Located in one of Clerkenwell's most ancient parts besides St James' Church, No. 15 Clerkenwell Close is the work of architect Amin Taha, who moved from Germany to the UK in the mid-1970s. Taha studied architecture at Edinburgh University after which he moved to London where he embarked on his architectural career first with Rick Mather, then at several other prestigious practices including Zaha Hadid in Clerkenwell. In 2013 Islington Council granted him planning permission to erect a seven-storey building that would include space for his home, his architectural practice Groupwork + Amin Taha, as well as seven flats. During the planning process Taha resubmitted and had plans agreed to replace the original planned bronze frontage with a load-bearing limestone façade, applying different finishes to the stones so that some would be rough-hewn with fossils while others would remain smooth, giving the building an unfinished appearance.

When the building was completed, Islington Council claimed that Taha had failed to obtain the necessary planning permission for his alterations, that the building was out of keeping with its historic neighbourhood and threatened to demolish it. Controversy raged for two years but Taha ultimately won his case and received planning consent in August 2019.

Station: Farringdon

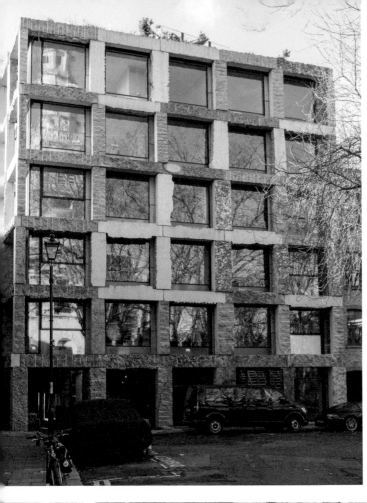

Left and below: No. 15 Clerkenwell Close.
(© A. McMurdo)

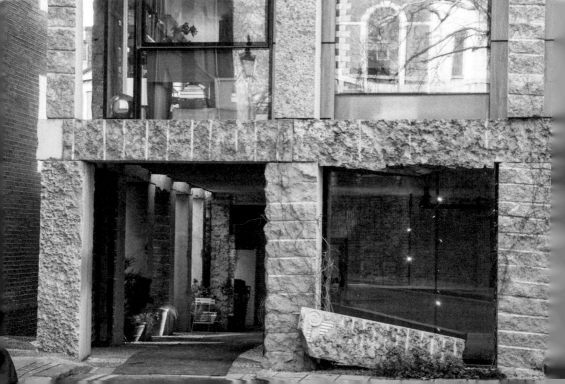

Further Information

There are far too many sources of information to list here but if you are inspired to find out more about the buildings described or about others in the borough of Islington, I would suggest you visit the Islington Local History Centre based in Finsbury Library at No. 245 St John Street.

Some useful websites are:
www.british-history.ac.uk
www.historicengland.org.uk
www.islington.gov.uk

Acknowledgements

The author would like to thank all the people and organisations that have facilitated the production of this book. In particular to acknowledge the help and assistance given by staff at the Marx Memorial Library, Wesley's Chapel and Leysian Mission, Union Chapel and British History Online.

I cannot emphasise enough the enormous role played by my husband, Alex McMurdo, who was responsible for the majority of the book's images. He has been a continual support while the book was being written and has accompanied me on numerous walks along the streets of Islington and Clerkenwell. I am further indebted to him and Jo for taking the time to proofread the text, for their feedback and constructive criticism.

I would also like to take this opportunity to thank Amberley Publishing for commissioning the book, and to acknowledge the excellent support and hard work of Angeline Wilcox, Jenny Stephens, Becky Cousins, and the team.

About the Author

Lucy McMurdo is a modern history graduate and native Londoner who has lived in the capital all her life. In 2003 when she qualified as a London Blue Badge Tourist Guide she combined two of her major loves, history and London, and has been sharing her knowledge of the city with local and foreign visitors ever since. Always keen to explore and learn about London's secrets, she spends many hours 'walking the streets' looking out for hidden corners, unusual curiosities as well as architecturally significant buildings and ones that have a story to tell.

Lucy's tour-guiding career began over thirty years ago when she first guided overseas visitors around the UK. Since then, in addition to tour guiding, she has been greatly involved in training and examining the next generation of tour guides. She has created, taught and run courses in London's University of Westminster and City University and also developed guide-training programmes for the warders and site guides at Hampton Court Palace.

Most recently Lucy has been writing about the city she is so passionate about and is the author of five London guidebooks: *Chiswick in 50 Buildings*, *Bloomsbury in 50 Buildings*, *Explore London's Square Mile*, *Streets of London* and *London in 7 Days*.